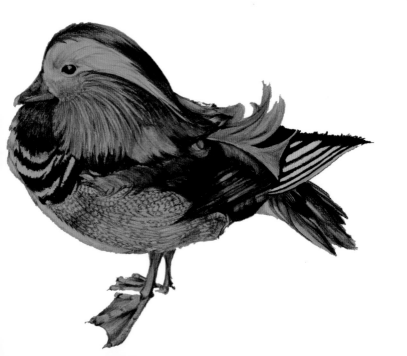

THE #100 Love Notes PROJECT

— a love story —

Hyong Yi

LORIMER PRESS
DAVIDSON, NC
2017

Editor, Leslie Rindoks

ISBN - 978-0-9961884-1-8
Library of Congress Control Number: 2016949878

Published by Lorimer Press
Davidson, NC

Printed in China

ADDITIONAL ACKNOWLEDGMENTS & PERMISSIONS

Art photographed by Kurt Rindoks

Page 2: Family Photo by Lindsay Hart, Hart to Hart Photography & Design; Page 24: Spanish Sardine, courtesy of the U.S. Department of the Interior, Fish and Wildlife Service, *Fishes of the Gulf of Maine*, H.B. Bigelow and W.C. Schroeder, 1953; Pages 18-19: Origami, folded by Joey O'Donnell; Page 31: Roses by Perolsson; Page 58: Clover by Stephanie L. Scyza; Page 59: Penny by Nathan Bauer; Page 170: Central Park statue photograph by Marianne Huebner; Page 197: Tiffany Window at St.Peter's photo by Marcee Rosar Musgrove, Whitelotusarts.com: Page 210: *Carolina Bride* cover, courtesy of *Carolina Bride*, with photo by Crystal Stokes Photography; Page 217, dust jacket: author photo by Val Lovelace.

*This book is dedicated to lovers whose forevers
turned out to be shorter than they planned.
May they find peace and comfort
in these words and images.*

In memory of

*Catherine Ann Zanga
March 11, 1973 — November 21, 2014*

contents

foreword

IF YOU ARE the type of person who reads the end of a book first, you've already read Hyong Yi's bio and know that he hankers for enough "street cred to call himself an artist." He need not worry. Who else but an artist could have envisioned creating something this exquisite from the core of his sorrow? Only an artist could have refined the heights and depths of 15 years into 100, three-line poems. And only an artist with a great heart could have entrusted those words to other artists, artists who have, with great passion, accepted his challenge and illustrated his 100 Love Notes.

If you did indeed begin at the front of this book, you may wonder why a Mandarin duck is the first image. Aside from the fact that they are known to mate for life, further research revealed that Mandarin ducks have loads of personality, and according to one source, they are "both spirited and comic." From his lively patterned socks, to his bow ties, and light-as-a-feather humor, this defines our author. Thus, the Mandarin has been cast as the mascot for *The #100 Love Notes Project* (and recurs as wedding favors in Notes #31-32).

Because the purpose of this volume was to delve into the stories within the stories, I spoke with many of the artists whose work is featured here. I spent a delightful afternoon with self-proclaimed "burnt-out banker"

Jen Walls, who's only been making art for five years, and who bounds into her studio each morning "still in my jammies," too excited to waste time getting dressed. (She describes the process of working with gelatin paper as addictive as crack.)

Columbian-born Luis Ardila revealed how he experienced absolution when illustrating Notes #89-90, sharing the story of his mother's death, confessing the guilt he had carried over being asleep when she passed.

Rebecca Haworth says she gained meaningful insights creating her multi-media pieces, work that forced her to process her own cancer battles. (However, don't expect titles to accompany her pieces; her own children had to wait more than a week before she bestowed them with names.)

I spent a morning with Diane Pike, who learned to paint while living in Denver, Colorado and now lives in Denver, North Carolina where her brushes continues to speak to the majesty of nature, whether it's full blown Rockies or the more understated hills of the Carolina Piedmont—gorgeous landscapes, warmed by an undercoating of pink, her signature.

Marianne Huebner dreamt in French, then created a masterpiece on a scroll of craft paper. She painted another on a recycled canvas that she liberated from a thrift store. (One of her pieces graces the notecard tucked into the back cover of this book.)

Special thanks must go to Jonathan Grauel, who in addition to the pieces he was initially assigned, stepped into the breach after a few pieces fell between the cracks and needed to be replaced. He did not hesitate, even in the midst of other deadlines and commitments, and we are in his debt.

Emily Andress must be singled out, not only for her emotionally charged pieces, with their roiling skies, but for her innate ability to pull people together, infuse them with a healthy dose of her enthusiasm, and keep them on task and on deadline. What she did is nothing short of a miracle. She ensured that 17 artists banded together, illustrated the pathos of 100 three-line poems in less than three months, enabling the myriad components of other creative endeavors to fall into place, allowing words and images to join forces so that a book could emerge.

Call it serendipity, the uncanny pairing of certain artists with certain notes, but I think artist Laura Grosch may have been more accurate. When reviewing an early draft of this book, she suggested that it may well have been Hyong's wife Catherine's hand at work, ever the planner, ever the organizer, knowing who should do what and when.

And no surprise, Catherine, once again, was right.

Leslie Rindoks, editor
Lorimer Press
Davidson, NC

preface & acknowledgments

a FRIEND AT CHARLOTTE'S Arts and Science Council introduced me, along with fellow Ciel Gallery artist Caroline Brown, to Hyong Yi in the fall of 2015. He had a project that was, at that point, just a seed of an idea.

I'm not going to lie; I am known for being a weeping willow. I have been this way all my life. (My Irish friends say my bladder is too close to my eyes.) As Hyong told us his story I cried. A lot. Buckets.

As the first anniversary of his wife Catherine's death approached, instead of allowing the grief to overtake him, he decided to write their story as a series of 100 love notes. He and his children, Anna and Alex, planned to hand these notes to people on the streets of Charlotte, North Carolina as a celebration of her life. Hyong envisioned taking this a step further and that's where we came in. He was looking for a group of artists to interpret the notes, turning them into a book, thereby illustrating their story.

Finding artists for this project was easy. Through Ciel Gallery, Caroline and I are connected to a large group of incredibly gifted and generous artists. Among them are: Tina Alberni, Luis Ardila, Caroline Brown, Avery Caswell, Jean Cauthen, Pam Goode, Jonathan Grauel, Rebecca Haworth, Laura Hitchcock, Marianne Huebner, Nick Napoletano, Diane Pike, Ria Rivera, CeCe Stronach, Jen Walls, and Samantha White. Once contacted, all agreed to participate in this joint project.

Caroline, Hyong, and I met over lunch to pair these artists with his notes. Caroline and I look back at this process as nothing short of magical. Through tears, we read the notes, looked at each other, and the same artists' names popped out of our mouths. At the time, we did not realize how deeply many of these pairings would resonate with the artists.

We invited the artists to the gallery to meet Hyong. He told us about their life together. He had with him dozens of origami cranes, a pair of wooden ducks (given as wedding favors), a pocket watch—all part of their story and tokens of inspiration. As we left that night, each one of us was unsure whether we could live up to the task of illustrating their love story.

When the subject matter became overwhelming, we reached out to one another for help. We worked through our own insecurities, and then worried that the resulting art would be too emotionally draining for Hyong. We cried alone in our studios; we got together and cried, too. Throughout it all, our focus was to tell the love story of Hyong and Catherine and to help create a legacy for their children.

Now, looking at all of our work collectively, it is amazing to see how each artist approached his or her part of the story. From the beginning, full of color and excitement, to the point when a sad reality strikes, it is clear how the energy changes in the work and the palettes of all the artists darkened as they worked toward the end.

To say that this project has changed us as artists would be an understatement.

Without exception, there has been growth in everyone's art, yet another legacy Hyong and Catherine have created.

The art in this book represents our love notes to Hyong and his children, and serves as a celebration of their legendary love.

Emily T. Andress
Partner, Ciel Gallery
Charlotte, NC

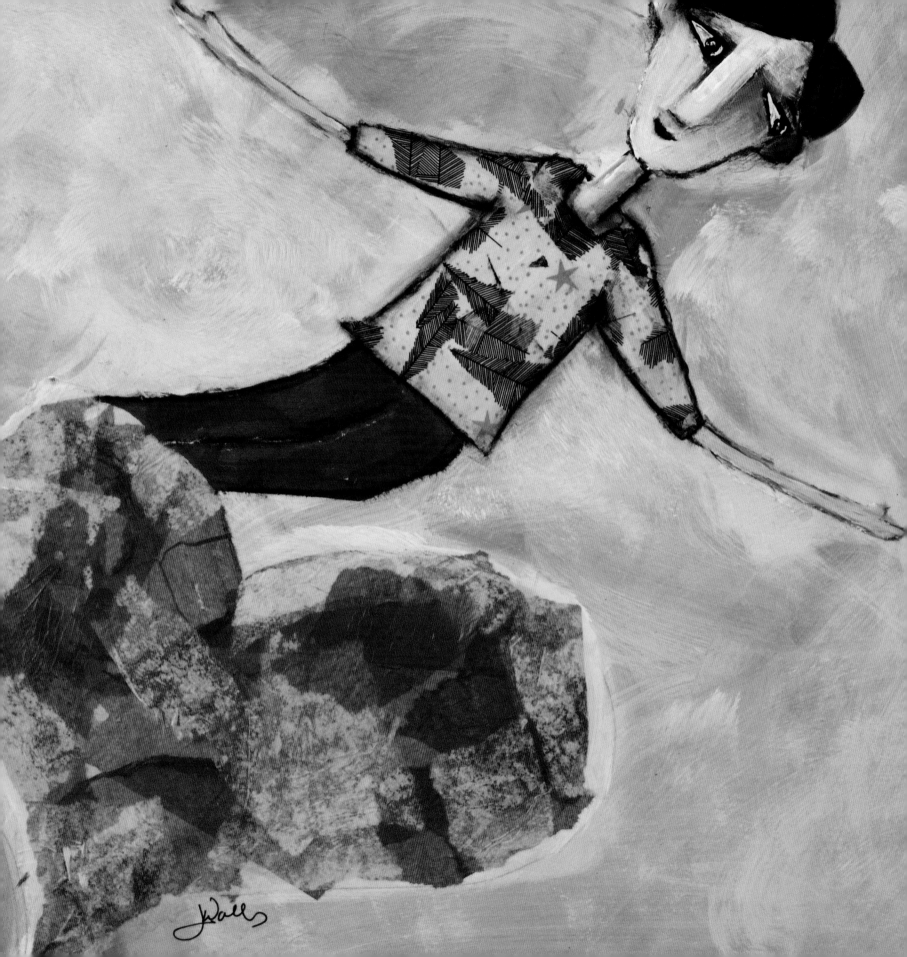

introduction

ONCE UPON A TIME, a man met a woman; the woman decided that she liked the man. They fell deeply in love and planned to live happily ever after. But the end, their ever after, sadly came far too soon.

. . .

This book should not exist. These words and beautiful images should not exist.

Early on, Catherine planned nearly every detail of our life together: She'd be a stay-at-home mom for a few years and build a strong relationship with our children Anna and Alex; we'd take family trips; make memories together in the Blue Ridge Mountains, at the Outer Banks of North Carolina, and all the wonderful spaces in between, up and down the east coast; raise well-adjusted children (as well-adjusted as kids can be these days) who were productive members of society; she'd re-enter the workforce doing what she loved—legal work protecting the weak and upholding justice in society; and when we were empty nesters, travel the world together and see all the fantastical, magical, mystical places we could find. This was how our life was supposed to unfold.

We were reminded in a very real way that sometimes forever lasts only a short while. We had not planned on stage IV ovarian cancer. Nor had we planned on the drugs failing to hold the cancer at bay. Hope began to die when the first drug failed. Our thinking about forever changed that day. For us, forever lasted 22 months.

During that time, Catherine chose to live as fiercely as possible. Our family of four traveled as much as we could so that she could say that she was the first to take the family:

- To a foreign country requiring a passport (the Bahamas)
- On a cruise (Disney Cruise to the Bahamas)
- To New York City, Cape Canaveral, Boston, Atlanta, Mammoth Cave National Park
- Hang gliding

In addition, we travelled to visit family, and said "Yes" to as many invitations as we could. For a time, despite the sadness hanging over us, it was the best year ever. Friends and family did everything possible to make it so for Catherine. We could pretend everything was okay even with chemotherapy infusions every two weeks reminding us that our reality was much scarier.

Reviewing our family road trip itinerary

On Thursday, November 20, 2014, the fourth and final doctor said that the last experimental treatment had failed. There was too much cancer for the drug to overcome. It was time to call hospice.

At Levine & Dickson Hospice House in Huntersville, North Carolina, holding her hand as dawn approached, I closed my eyes for just a second—

In that moment forever died.

It seems as if that day, that week, and the ensuing year passed in a blur. As a widower, and now a single father of two young children, I grieved alone, with my children, with friends, and with the community. I shared my grief journey with my friends, near and far, and with Catherine's friends, whom I adopted. (Facebook is good for something!) I chronicled my family's journey for a year, just as Catherine had shared her cancer journey.

As the first year anniversary of her death approached, I faced a dilemma. With each passing day, I could see that date approaching. In September, I did the math, counting the remaining days; this did not evoke any sense of comfort. Like watching a hurricane building in the Atlantic, I could hunker down and ride out the

pending storm as best as I could, then deal with the wreckage afterwards. Or, I could come up with a more satisfying and less passive plan.

What to do? How could I attack the anniversary of her death so that I could actively fly through the hurricane and not let it consume me?

If I had learned anything from losing Catherine, it was how precious and important love is—it is the most important thing in life. And I had not learned this until I had lost the love of my life. I found myself sharing my hard-learned lesson when public speaking opportunities arose.

It became clear that the best way to honor her love was to share, on the anniversary of her death, the lesson I had learned.

I wrote 100 love notes—notes, not letters because letters are too long—covering the entirety of our 15 years together: How we met. How we dated. How, over time, anxiety transforms into confidence and blossoms into love. The knitting of two, then three, then four lives into one. The fear and hope that comes with the word "cancer." The living that happens when you know you're running out of time. The desperate sadness that accompanies every moment. The struggle to find a new path.

On November 20, 2015, on a Friday morning, I took

Anna and Alex to Trade and Tryon Streets in Charlotte. Over the next hour, we shared our love story with 100 strangers and encouraged others to take a moment to remember the love in their lives.

That hour had a bigger impact than I could have ever imagined. The positive response that streamed in from around the world was a reminder that everyone knows what love is, and sometimes we all need a prompt to take a moment from our busy lives to honor love.

And thus, here we are—*100 Love Notes*, the book.

It's difficult to squeeze 15 years into 100 short poems, but these notes are my attempt.

This book allows me to honor her. I hope it inspires you.

Hyong Yi
Charlotte, NC
July, 2016

W E MET ON A Sunday morning when a mutual friend (for me, from high school; for Catherine, from the University of Virginia) introduced us, and we all went to church together. As a newly minted attorney, Catherine's only free time was on Sunday.

I was coming off a heart wrenching break-up; she had just moved to the D.C. area and didn't know anyone.

I had a desire to do things, but not alone. So I asked her—to bike rides on the C&O Canal in Georgetown; to symphony concerts (I had bought tickets months in advance)—to a bunch of things.

Initially, my intent was just to have a friend so I didn't have to do these things by myself.

I wasn't really interested in dating.

She wasn't really interested in dating, either.

And after several rounds of her saying, "I'm not interested in dating," and me replying, "I know. Neither am I," we eventually began to enjoy bike rides and concerts and having dinner together. ▼

First Date

Hyong and Catherine's first date, from my perspective, was like the beginning of a fairy tale.

Focusing on the hopefulness in the words, I chose bright and cheerful colors and gave the scene a romantic feel by leaning the bikes against the tree, close to one another.

I imagined a couple just getting to know each other, leaning against the tree, circling one another in the first blush of flirtation. The picnic basket and blanket give the impression of more

thought being given to this casual "bike ride."

The tree is full of apples (ah, temptation!); there is a green apple in the picnic basket, and daisies, too, calling to mind, "He loves me/he loves me not."

Clearly, both are testing the waters as he claims to be asking for "a buddy" and she claims to have no interest in dating.

—Emily T. Andress

Dearest,

 Hi. I'm not asking much.
Only a partner for a bike ride,
 a buddy so I'm not alone.

 —Beloved

1

Beloved,
 I'm not
interested in dating,

but I am new
 to D.C.

Okay, I'll go.
Will there be food?
 — Dearest

Dearest,
You just ate a whole Spanish anchovy!
The other one's for me?! Nope.
I licked it, but I'm not eating it.
—Beloved

Beloved,

 Follow me to the top of the mountain.
 Hold my hand;
 I'm afraid of falling.
 Don't let me go.

 — Dearest

I created this set of love notes in the same way that I make my mixed media paintings. Every piece is made of many layers of words, collage, paint, and pattern.

I began by writing the words "Beloved" and "Dearest" on paper, to create a first layer, embedding Catherine and Hyong's story in the process. I chose elements from each note as my images. (Here, it's the Spanish anchovies.)*

—Caroline Brown

* Spanish anchovies, aka Boquerones, are known in English as "white anchovies" due to the color of the meat in the fillets. They are preserved and flavored in either olive oil or vinegar, or both, often with a hint of garlic.

▲

- 3 -

Eventually, we both realized that our interest wasn't just
companionship, but attraction. It culminated during a
Friday night date at a Spanish tapas restaurant in
Washington, D.C. called Jaleo (which is still around).
It was packed so we sat at the bar.
We shared small plates, including one of Spanish
anchovies, complete with scales, tails, and heads.
She ate one and said the other was for me.
I picked it up and licked it, and
despite my desire to impress her,
I couldn't eat it.

She ate them both.

- 4 -

Fortunately, she didn't think any less of me.
We went on many dates together. Trips to the
Virginia wineries and her alma mater,
the University of Virginia. We hiked mountains,
including Old Rag, a prominent mountain with a great
view. We climbed the switchbacks and got to the granite
outcropping. A few moments are scary to a novice, so I
helped her get to the top of the mountain,
over the difficult scrambles and jumps.
Eventually, we got to the top and enjoyed the
360 degree view of the valley.

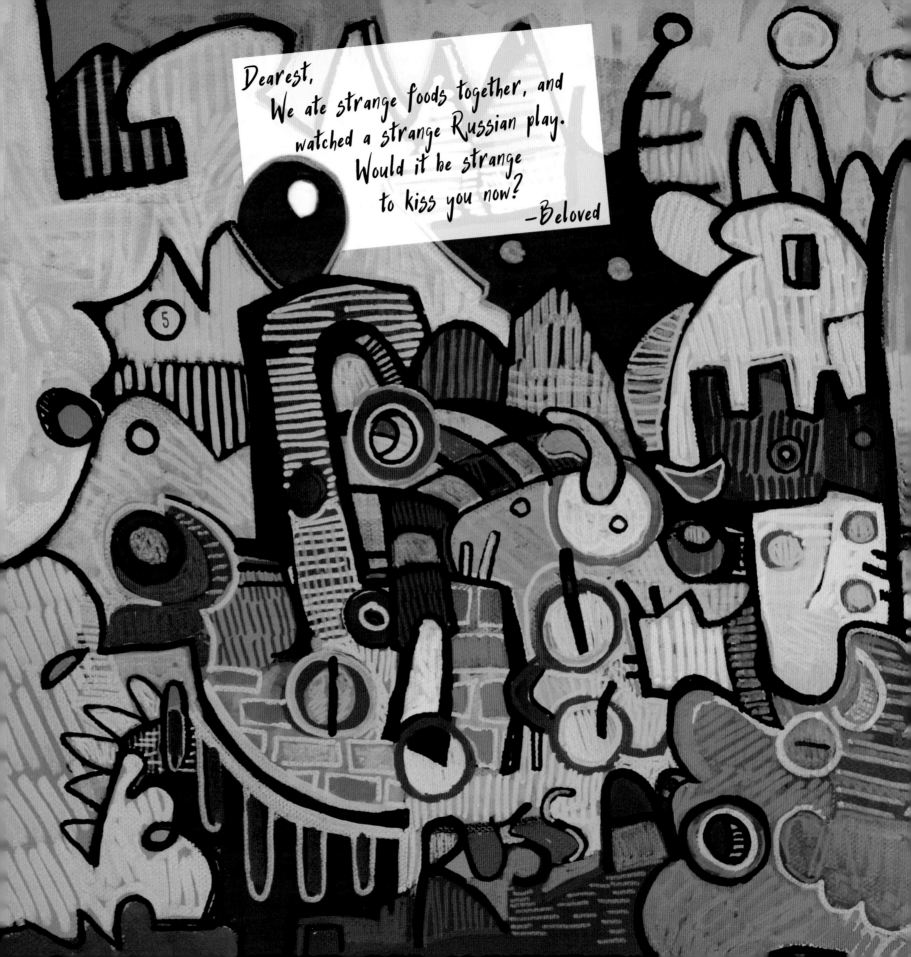

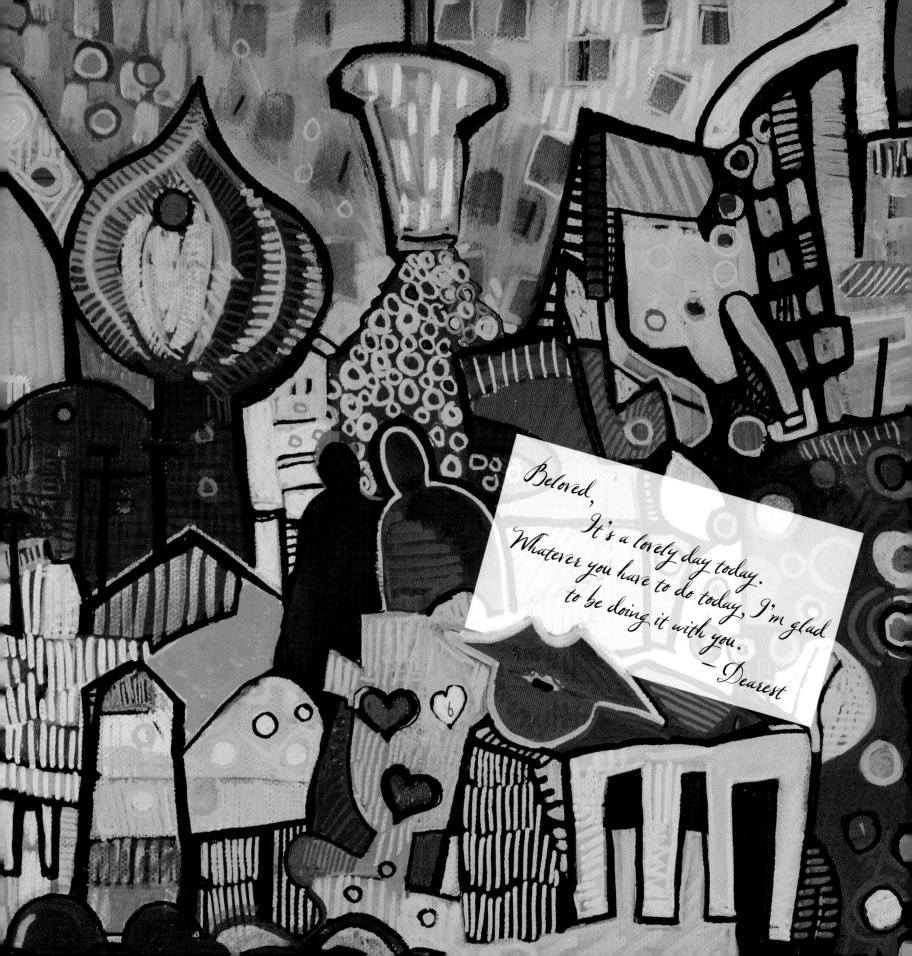

Together We Are Strange & Familiar

I love to layer! No matter what medium I work in, the process of building layers upon layers is always key. I sketch in lines, layer shapes of color, then layer more lines.

I selected words from these notes (for this one, Russia and kiss) and wrote them on the canvas. I let the imagery they conjured roll around in my head, then grappled with similar shapes and lines. Some of the words still peek through.

More than the specifics of where they were, I sought the playful energy of a first date—the nervousness and uncertainty. This piece represents the excitement and wonder of multiple moments that were the beginnings of a new relationship.

— Jonathan Grauel

▲

Then you reach a point in the relationship
where just spending time together (being
companions and buddies for events) isn't enough.

Now you want to spend every day together
and have all the privileges that accompany
mutual attraction and love.

Ours was not a direct route. Clinging to our
initial proclamations of "I'm not looking for a
relationship," we ate things we didn't want to eat,
attended events that we didn't understand, and took
late night walks in neighborhoods that were probably
not that safe—just so we could spend time together.

Then, holding hands during a walk to
Lincoln Park near the Capitol Building,
we kissed for the first time.

— 6 —

What joy ensues when a heart
finds its partner. Whether it's sunny or rainy,
hot or cold, day or night,
the heart doesn't care!

It's always a beautiful day
when there is someone
to share it with you.

The mundane becomes
extraordinary!

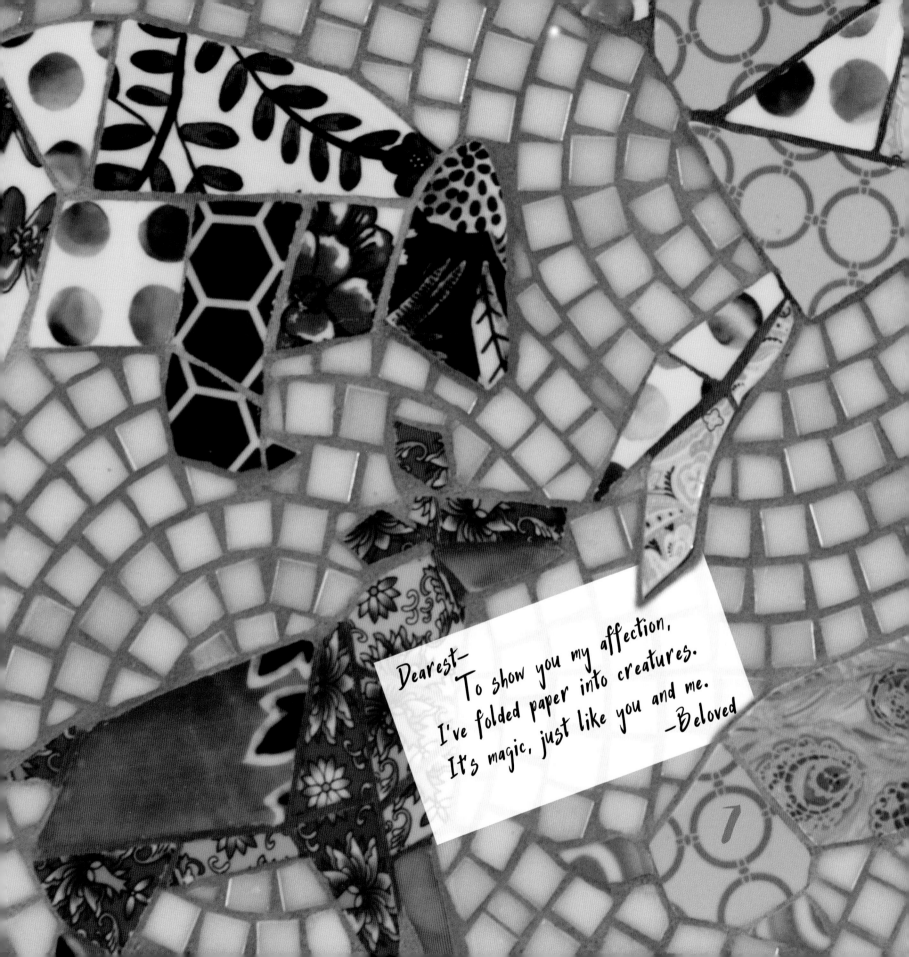

Dearest—
To show you my affection,
I've folded paper into creatures.
It's magic, just like you and me.
—Beloved

Beloved,
 You sing the song in your heart
accompanying me on the sidewalk.
 I think you might be crazy.
 — Dearest

I DID A LOT—*a lot*—of origami to impress Catherine. Cats, dogs, peacocks from dollar bills, hippos, bears, you name it, I did it. It took hours.

— 7 —

In the extraordinary, we find ways to woo another heart. The imagination runs wild; creativity spills from the brain and heart to the finger tips. Affection gives birth to a multitude of creatures—bears, dogs, cats, cranes, elephants, peacocks, and many many others—just so that she can know how magical it is to share the days with her.

— 8 —

But love can't simply be expressed through paper. The heart sings songs of love and often it's in public. Walking down the sidewalk for instance. But when you're in love the whole world needs to know. Or so I thought. For Catherine, singing publicly while walking down the street was a sign of insanity, leading her to wonder, "What have I gotten myself into?"

There are times when inspiration is a clear path, and times when you can't quite explain the connection but feel it in your soul.

I'm so in love with the mental images of Hyong compulsively folding multi-colored papers into raucously child-like animals as a representation of his blossoming love for Catherine, as well as her slight reluctance toward a man who feels no desire to mask his affection.

Patterned china pairs steadfast ceramic with fragile paper and sets his offering of love in stone, so to speak. I see Hyong as the exuberantly smitten elephant-in-the-room, while Catherine and society-at-large give him the once over to determine if he is for real or, perhaps, just a little bit crazy. (A little-bit-crazy is always best.)

—Pam Goode

Within Each Other

I felt husband and wife honored and adored the love they shared, in each moment, and at every step of the way, as their lives interwove. They each held onto the other tightly and lovingly, and walked through life in concert. I tried to capture a moment in time of complete happiness with ever-present light and love.

—Tina M. Alberni

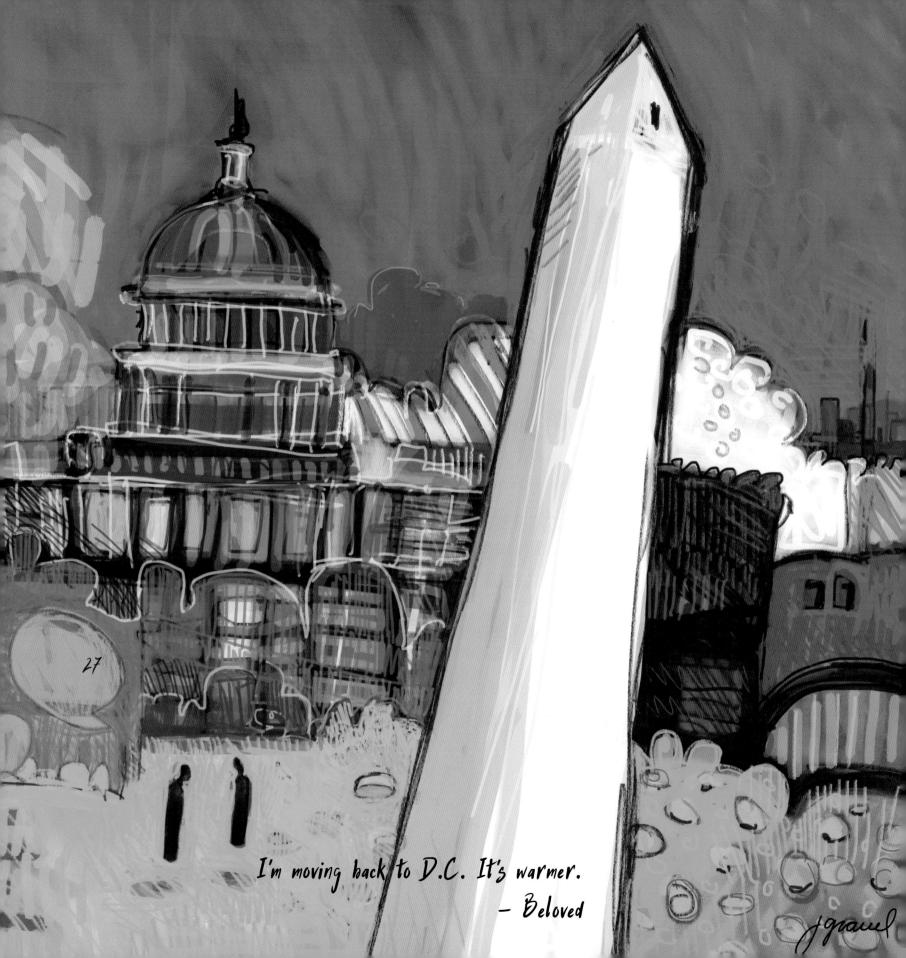

27

I'm moving back to D.C. It's warmer.
— Beloved

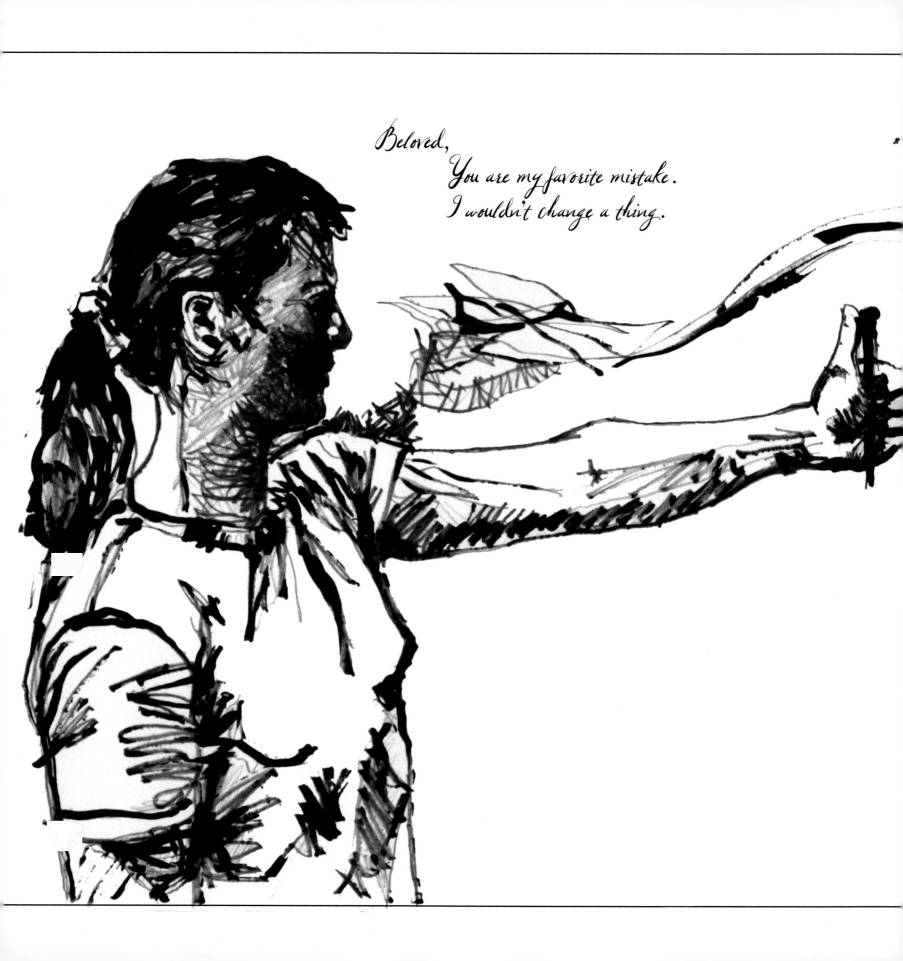

Beloved,
You are my favorite mistake.
I wouldn't change a thing.

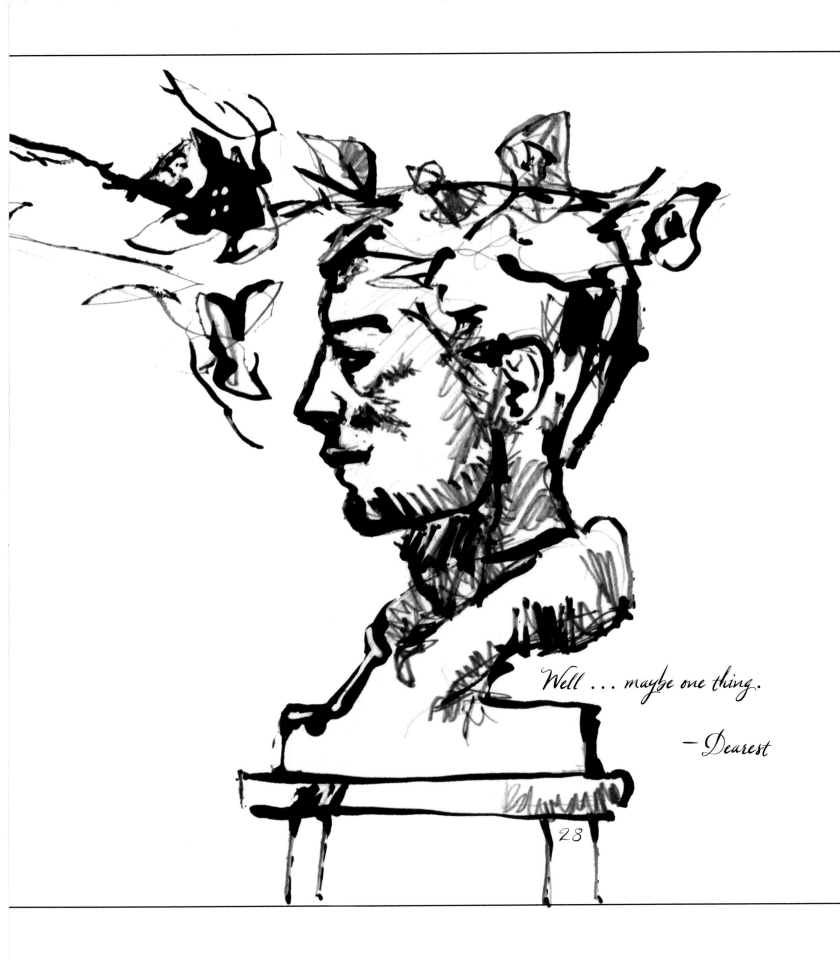

Well . . . maybe one thing.

— Dearest

28

— 29 —

For Catholics, one of the pre-marital activities
is Pre-Cana, a consultation for couples preparing
to be married in a Catholic church.

As part of that program, we both took a test.
The priest counseling us said that in all his years
doing this, he had never seen two people so far apart
on the "compatability" test.

He asked us, "Are you SURE you want to get married?"
Of course, I answered, "Yes," but my response didn't
have the conviction that it should have.

The test (and the priest) shook our faith a bit.

Love Note #29 is my response to
that compatability test.

A test is not going to determine who I love.

— 30 —

Driving down Interstate 95 to southern Virginia,
Catherine said two things in the space of a few minutes.
First, "Please keep up with traffic."

Which made sense given that everyone was speeding.

Second, a few minutes later,
she said, "Please do the speed limit."

The problem was that these requests—as politely asked
as they were—were mutually exclusive. I could only do
one and told her so.

She agreed that I couldn't do both.

This may have been the only argument
that I ever won decisively. ▼

Green Means Go

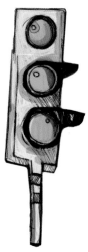

What would best represent a test of love? I began with a pencil and the typical test bubble sheet. Pencils became buildings; bubbles filled in everywhere. The palette derives from the blue of test sheets and the color of #2 pencils. To maintain a sense of playfulness, notice that the stoplight is all "go," and the way forward, in the midst of back to back traffic, is clearly a two-way street.

The hidden figures in my work, the "traveling men," represent points in time, states in our lives, and call attention to those significant moments. The towers, bridges, archways become dialogue to help relate the story of man's journey. Bridges are also a symbol—we go over and under things as we progress in a relationship. Arches are about decision-making; here there are two significant arches, two decisions.

— Jonathan Grauel

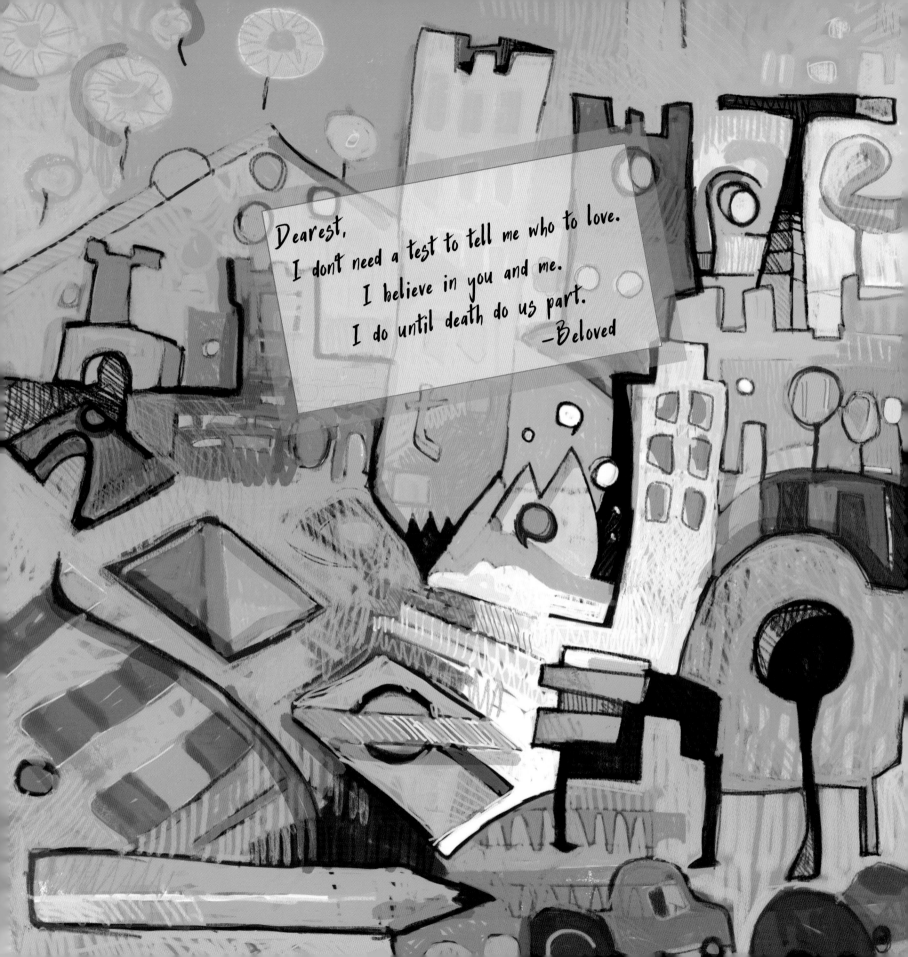

Dearest,
I dont need a test to tell me who to love.
I believe in you and me.
I do until death do us part.
—Beloved

Beloved,
 Please keep up with traffic...
 Please drive the speed limit...
 I know they are mutually exclusive.
 —Dearest

Dearest,
These wooden ducks
are our wedding favors.

Mandarin ducks
mate for life and

if one dies,
the other mourns.
—Beloved

Beloved,
 I have gazed into your heart and soul.
I know you better than you know yourself.
Here's a pocket watch for you as proof.
— Dearest

Wedding favors and the gift of a pocket watch illustrate this set of poems. Hyong gave me a set of wooden Mandarins that he and Catherine used as wedding favors and the pocket watch from Catherine for reference.

I love painting birds and considered painting real Mandarins, but decided to use the actual wedding favors and so I set up a still life to paint. The background became an abstraction of reeds in water that encircled the ducks and the watch, holding them together.

This was a happy time and the joyful palette reflects this.

—Diane Pike

▲

– 31 –

At last we were married!
As part of our wedding, we handed out wooden ducks
which I had a Korean uncle ship in a big cardboard box.
Who ships 100 pairs of wooden ducks?!

But the important fact about *these* ducks are that
they are Mandarin ducks. Mandarin ducks
are monogamous and mate for life.
In Korean culture, they are a symbol of fidelity
and great love.

The end of Love Note #31 foreshadows our future.

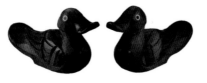

– 32 –

But we still had a lot of life to live.

Catherine was the best gift giver I have ever known
—my engagement watch, a brass pocket watch, a camera—

all evidence that she knew my soul
(and that the Pre-Cana compatability test was way off)
!

THERE WAS ONE argument that Catherine and I never settled. One day, my Volkswagen Jetta VR6 (Greta as I called her) went missing from her parking spot. Just an empty parking space greeted me as I walked out one morning on my way to work.

My car had been stolen!

As I told Catherine what had happened, she asked me if I had locked the doors. Of course I had locked the doors! Who would be stupid enough to forget to lock the doors?

This argument occurred occasionally throughout our marriage. Catherine never budged from her belief that I had most likely failed to lock the doors, making poor Greta an easy target. I never budged from my position that I had most definitely locked my doors, meaning that obviously Greta had been stolen because she was a such a hot-looking machine.

The car was never recovered so we will never know.

▼

Ripe Plums

For me, note #33 contrasts the panic of
"OMG-where's-my-car!"
with the serenity that comes from knowing that
love winds through every day.

Oh, my car is stolen? Well let's just sit
beneath this delightful plum tree,
because when I look in your eyes,
who cares about a car?

Aack, I loved that Jetta!

But I have you, and the plums are ripe,
and I see our love everywhere I look.

(Ripe Plums is composed of glass, mirror,
and millefiori.)

—Pam Goode

Dearest,
It's okay if you fail the NC Bar Exam.

You were eight months pregnant.

Wait, the letter says you passed.

—Beloved

Beloved,

She is beautiful.

The best of both of us.

Look at her eyelashes!

— Dearest

▲

A S WE SETTLED into our life together, I sat in a blue Honda Accord in an NC State University parking lot for two days while Catherine took the North Carolina Bar Exam, eight months pregnant.

On April 4, 2005, she gave birth to our daughter Anna. The letter from the NC Bar arrived while she was in the hospital. I tried to manage her expectations by telling her that it was just practice and she shouldn't be upset if she didn't pass. Reading the letter to her (Catherine didn't want to read it), I was as surprised as she was when I got to the part which said that she passed the exam to practice law in North Carolina.

It made a beautiful day even better.

Anna was a beautiful baby. She is the best of both of us. She had beautiful eyes, but what really stood out were her eyelashes. They were incredibly long and the envy of every adult woman who looked at her.

For this piece, I thought back to when my first child was born. I remember holding her for the first time and wondering how this perfect little angel could possibly be mine.

My mother used to refer to family history that took place before I was born as, "That's when you were still in Heaven." As a child, I thought people just floated around on clouds waiting to be born. And everyone had wings, of course. And those wings linger for a bit after a child is first born.

Here, the baby is still so new that her wings have not quite disappeared yet. The baby seems to have flown straight into her mother's arms.

On the other hand, Lady Justice looks on smiling, holding her scales delicately so that they remain balanced which, as any working mother with a child knows, is harder than it looks. We find here two overwhelming accomplishments at one time.

—Emily T. Andress

Dearest,

It's a beautiful day!

Come outside and play.

It won't be like

this forever.

—Beloved

Beloved,
 I'm pregnant. Again.
That makes two and us four.
 I think that's enough.
 —Dearest

I'm Pregnant Again

Of the four pieces I did for this project, this was the hardest. I could not ignore the sense of conflict—it carved itself into the board.

I painted the heartbeats of the baby and the mother. Her heartbeat I could see ending. The boy reaches out, but does not touch her. She looks a bit haunted as if she's already gone. Her daughter hangs back, sensing that something big is coming, but she's too young to fully grasp it.

With the father, there is no sadness—just adoration and joy. He is nerdily adorable, the unsung hero. Obviously, she is the worrier.

Fate has already written this story...
There can't be happiness without sadness.

—Jen Walls

▲

— 45 —
Having moved to Charlotte to find a higher quality of life, we still found ourselves busy.
 Busy with work.
 Busy with community.
 Busy with child.
 Busy laying plans and building a future.

Still, we tried to take time to enjoy life.

The weather is nicer here and we have a daughter who is joy!

How could we not enjoy the beautiful days?

— 46 —
Enjoying the beautiful days led us to have a second child.

Anna was so easy as a baby that we decided that we could handle a second child.

(Alex changed our minds about having more children.)

A family of four, a girl and a boy. It seemed that everything was going according to plan.

— 47 —

My contribution to this growing family was
to take care of Alex during the night hours.
I'd get up at night to feed and change him,
giving Catherine a chance
to sleep through the night.

This was how I showed Catherine
that I loved her.

— 48 —

It grew increasingly difficult
to balance all our competing goals—
family, work, kids, each other.

New Year's Eve 2010, while I was home
with the kids, Catherine was at
Charlotte-Mecklenburg Police
Department headquarters
working on a legal brief.
She didn't get home until after 8 p.m.
She realized that as important as justice
was to her, it wasn't more important
than her children.

She wanted to spend more time with her kids
so that they would know her.

It took several months of planning, but she
eventually quit her job to focus on what was most
important to her—Anna, Alex, and me.

▼

Just Us Family

*I have a girl and boy myself; there's a neat unity
with having both a son and a daughter.*

*I sought the joyful and expectant shapes of family,
and explored the sacrifice that
making a family entails.*

*You can see night progressing into dawn.
To denote the dichotomy between sleep and energy,
I employed complimentary colors.*

*The family stands on the other side of a large arch,
signifying a big decision, in this case to
start a family. They stand together in a courtyard,
anticipating the adventures ahead.*

*Catherine's purpose is still there. Look for the scales
of justice—they are now a mobile
over the baby's crib.*

—Jonathan Grauel

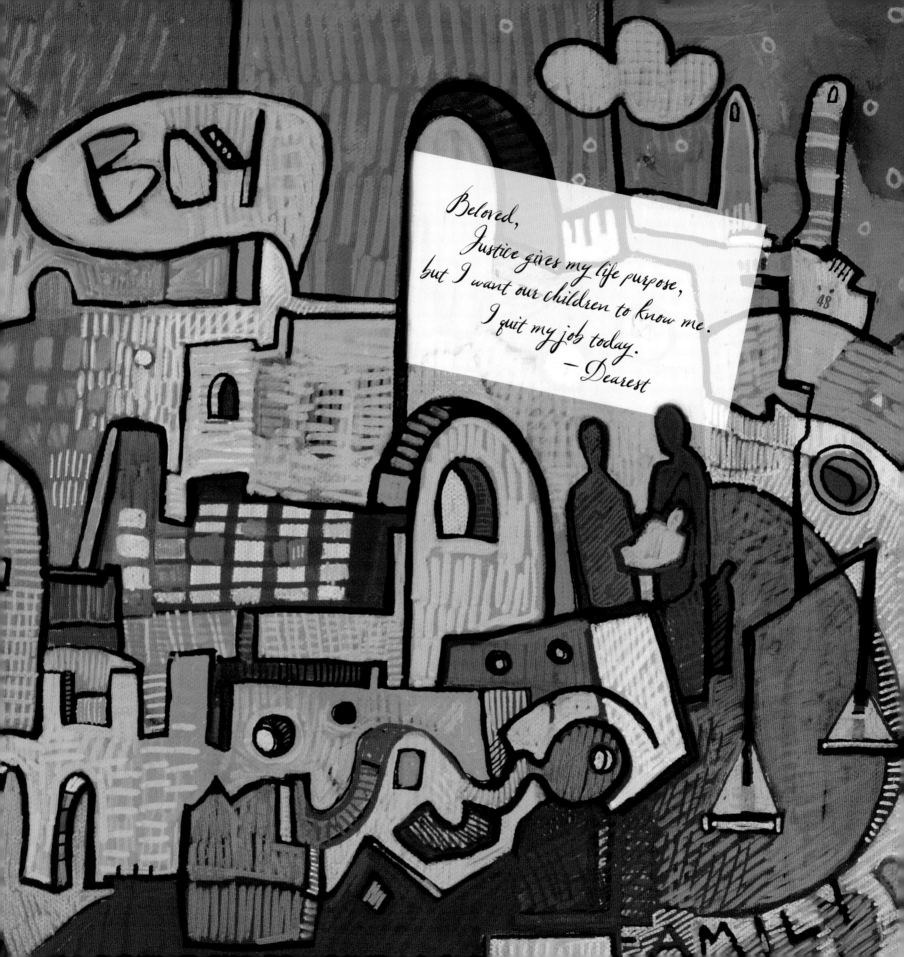

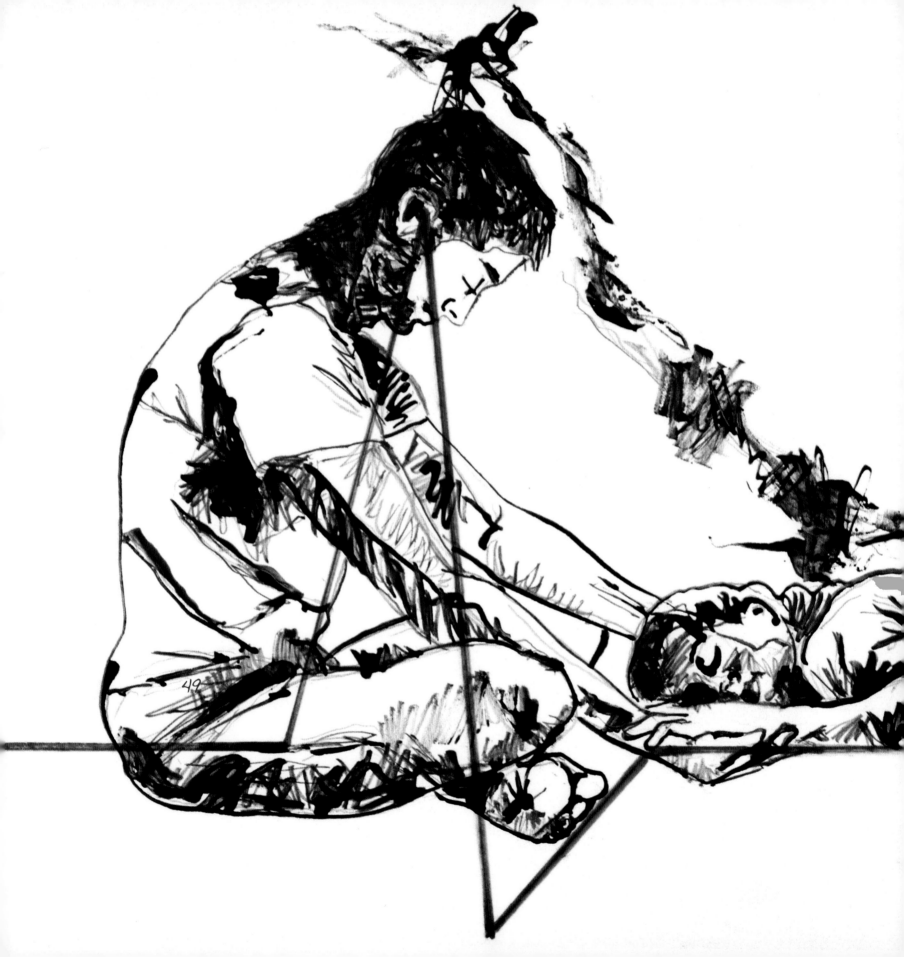

Dearest,
Everything you do, you do for us.
Everything I do, I do for you.
These are our daily acts of love.
—Beloved

Beloved,
I have known one great love.
Can you hold me in the quiet
between our heartbeats?
— Dearest

50

▲

– 49 & 50 –

A S WE RETHOUGHT our family as a one-income entity, we learned quite a bit about ourselves.

Catherine took care of us. She figured out all that we needed as a family and made it happen.

Everything I did, I did for her. She loved the family so I could love her. These were our acts of love, our daily demonstration of love to each other.

With children's activities, volunteer commitments, running the family, and everything else, it felt like Catherine was busier not working. Finding time for us in the whirlwind of life was a challenge. But every once in a while, we would find a pause in the hectic world to share what we meant to each other.

We didn't often get sappy, but we did talk about the one great love. And in that moment, it was as if all the craziness stopped and it was just us together in the quiet—the quiet that exists between heartbeats.

The flow of the blood into our hearts and the flow of air into our lungs are what makes us, by medical definition, living beings.

I chose a graphic, the simplest one, obtained from an electrocardiogram, to represent the rhythm of the heart. The more calm a person becomes, the bigger the gap between heartbeats. I saw blue for this graphic because it is a relaxing color, one that cools you; calms you; de-stresses you.

Then I embedded the couple within this graph.

Catherine rests in the silence between beats, and in that small space of time, is in ecstasy. They are sharing a rhythm of love, a rhythm of sharing things; an instant of life.

The graphic energy extends from his head to his toe. When it touches her at her heart a peaceful wave emanates. There is a flow, like a river, stringing along with the lovers, tracing from one point to the other, from the creek to the ocean, from head to toe.

—Luis G. Ardila

These two love notes carried so many poignant images that the challenge became how to pare down to an essential meaning. So many literal incarnations included cars, piles of dishes, roads, and even the relationship between labor and management.

Finally, the idea of a landscape with suggestions of uncertainty, beauty, and journey became the symbol for the road ahead. Simple checkered curtains imply the beats and rhythms of domesticity and family that continue throughout this long drive. They rustle, disturbed in the breeze. But their rhythms continue, nonetheless.

—Jean Cauthen

– 51 & 52 –

AS THE SOLE provider for the family, I spent all day making decisions and managing people. I loved my job, but it required a lot of mental energy. Coming home at the end of the day, I didn't want to make more decisions; I had what is commonly called decision fatigue.

Catherine was the brain of the household, she made all the decisions from what was for dinner to what bills to pay to where we were going on vacation.

We made this work in that I was the labor that executed her plans at home. And the best part was that I didn't have to think.

That doesn't mean that everything was perfect. One of the things that I always found aggravating was that when we would take vacations, we couldn't leave the house until everything was clean. The car would be packed. The kids would be strapped in and ready to go. And I would be waiting for her. We couldn't leave until the kitchen was clean; that meant no dishes in the sink.

You would think that over the years, I would have learned my lesson and have the sink empty on the morning we were to leave for a trip, but sometimes, a man never learns.

▼

Dearest,
 I've made decisions all day.
 Be my brain and guide me.
I can be labor to your management.
 —Beloved

Beloved,
 Pack the car. Strap in the kids.
It's a long drive where we're going,
 but first we should do the dishes.
 —Dearest

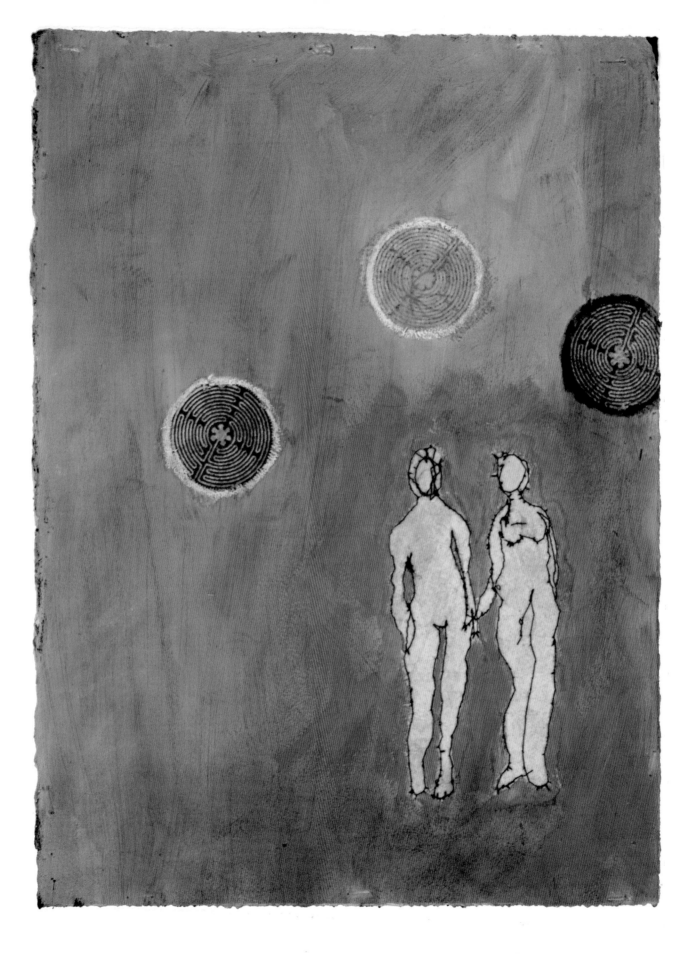

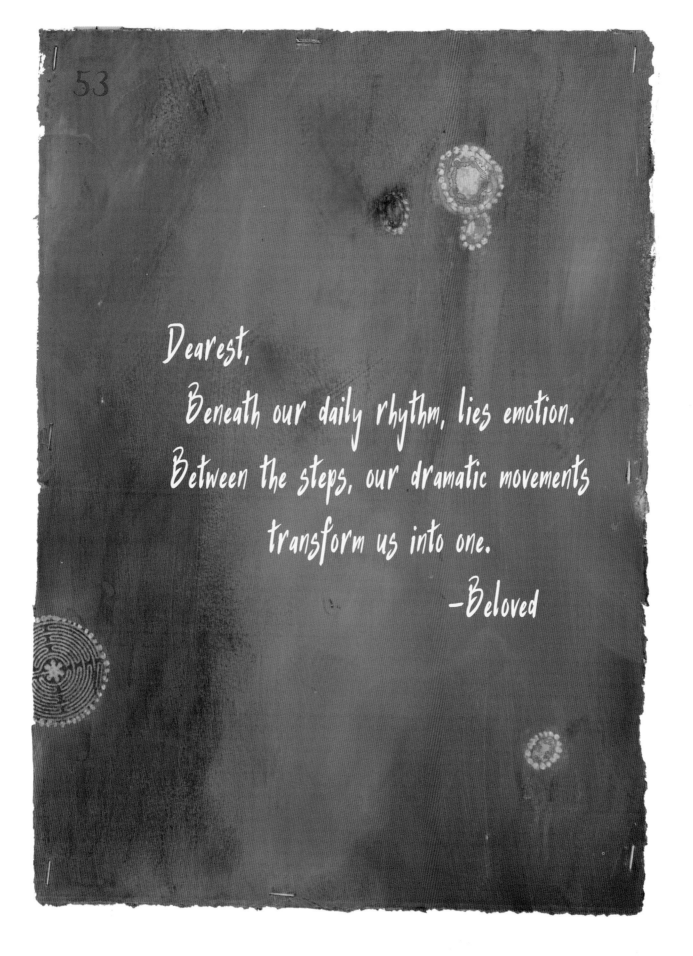

Dearest,
 Beneath our daily rhythm, lies emotion.
Between the steps, our dramatic movements
 transform us into one.

 —Beloved

▲

— 53 —

Like two dancers who have
trained together for years,
we learned to move as one.

The daily rhythm had ebbs and flows
that we learned to anticipate, but it was all
underpinned by love.

As we learned the steps to our dance,
the position of the hands, the arch of the back,
the position of the body—these
coordinated movements made us one.

Better together than alone.

Here the figures are surrounded by the red of passion—they're together; they're innocent; unaware.

They are walking together.

The labyrinths are a metaphor for life. Unlike a maze, a labyrinth is unicursal in that it has only one non-branching path, which leads to the center then back out the same way.

As with life, we end where we began. There is only one entry/exit point.

The irregular cells become more numerous and prevalent in the images, depicting the way cancer mutates and attempts to gain control over our bodies. In these pieces, a few cells float nearly unnoticed among the labyrinths.

—Rebecca Haworth

I actually enjoy doing laundry and sort whites from the mediums, darks, and towels with zeal. I admit to having found pleasure ironing my daughters' dresses, all those little pleats, ruffles, and pin tucks. It is a gift offered to my family (not that it is perceived as such). There is such satisfaction in making what was dirty, stained, and rumpled clean and crisp again. It is a way of bringing order to chaos.

Catherine must have felt the same about the household tasks that she performed for her family. Those details were important and lovingly attended.

A nod to the future looks at the past with a woman standing at a wringer washer, her white-as-snow laundry clearly separated from the colorful garden of wash going through the wringer. The "sheet music" on her line reminds us to dance now, before the music blows away completely.

—Avery Caswell

— 54 —

As idealistic and romantic
as these sentiments might be,
Catherine was never far from the practical.

She acknowledged the love and romance, but
would always make sure that we were
grounded in reality and what needed doing.

Yes, we can dance under the full moon,
but we still have chores to do
in order to make this family work,
laundry being chief among them.

▼

Beloved,
No matter what the future holds,
always remember to dance . . .
and separate the colors from the whites.
— Dearest

54

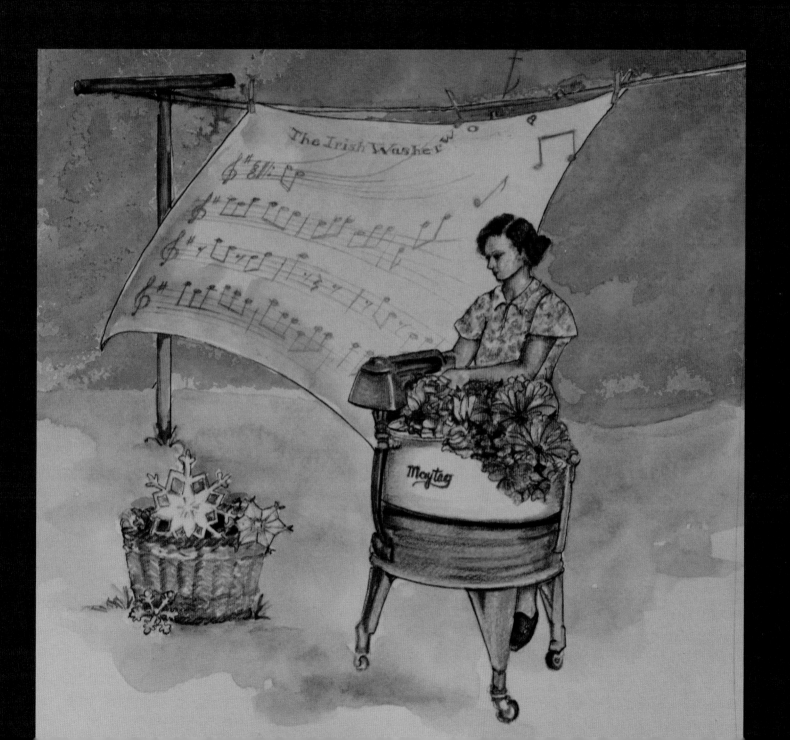

Dearest,
People come into our lives for a reason,
and I know who I am because of you.
You are a handprint on my heart.
 —Beloved

Beloved,
We've travelled so far —from piedmont
to desert, river to mountain.
I feel the grandness of this land. Home.
— Dearest

▲

— 55 —

Over our 15 years together, Catherine and I
found each other, built a family, loved and fought,
fought and loved—but we stayed together because
we loved each other.

We were the greatest loves in
each other's lives.

We often don't know why people come into our lives,
but the best thing we can do is embrace it when they do
and be changed forever.

I know that I'm not the same person before and after Catherine.

I'm better.
I know what love is.
I know how to love.

I know her handprint will forever be on my heart.

— 56 —

Although we didn't realize it at the time,
the last stage of our journey started in July, 2012.

We drove from Charlotte to Albuquerque, New Mexico
and then to the Grand Canyon, Monument Valley, Mesa Verde, Colorado,
several national parks, and Denver, Colorado.

At the rim of the Grand Canyon, Catherine shed tears.
Its beauty overwhelmed her.

Standing there also allowed her to check an item off of her bucket list.

I must have read these notes 100 times.

There are moments when we stop and consider our lives; this was one of them.

As Hyong expresses Catherine's importance in his life, it feels like a moment of serene and genuine gratitude.

Paired with Catherine's experience of traveling and finding comfort in vastness of space, these two notes led me to a place of peaceful contemplation.

I envisioned the couple lying under the stars, holding hands, looking up, and being mesmerized by the life and love ahead of them.

—Samantha White

Dearest,

In the spaces in between,

live the little acts of love

that unite us as a family.

—Beloved

57

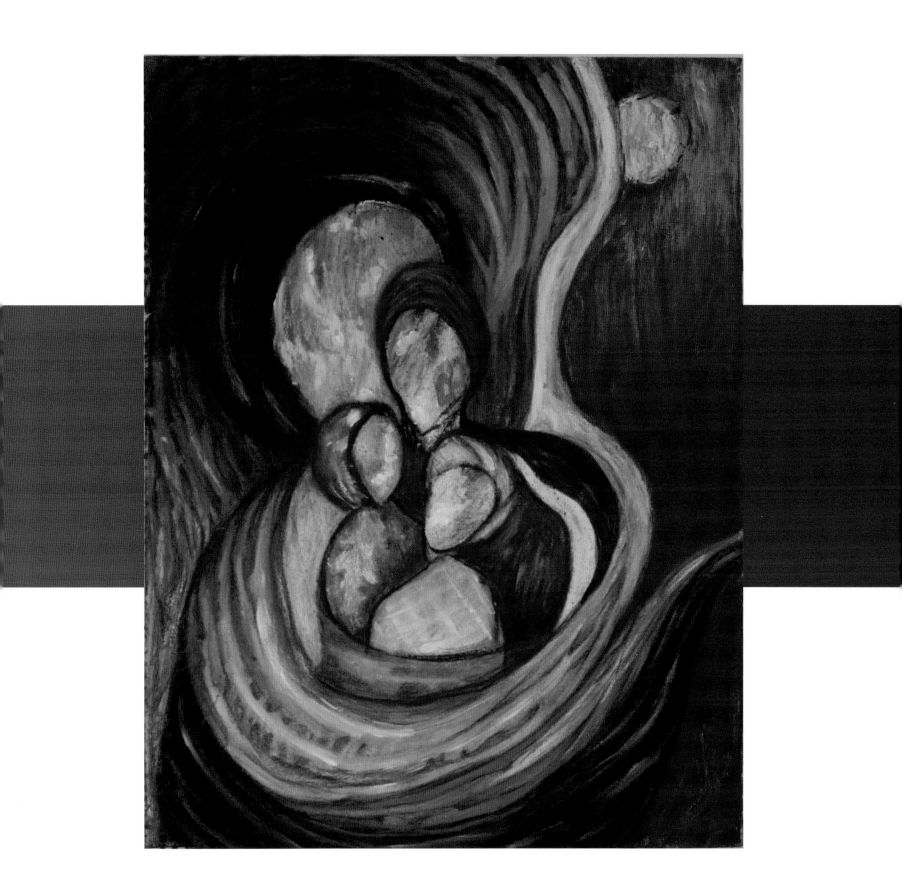

If you think of the big things in life
(spouse, kids, job, house, etc.) as balls,
there's always space between.

In those spaces,
we find the little things.

Her: Planning a three-week trip in great detail—
every restaurant, every hotel, every national park.

Me: Packing and unpacking the car.

It's in these little spaces
that we grow as a family.

Unconditional Love

I felt an intense love surrounding this family and was compelled to represent the mother's constant presence, together, as one, in unity always, and without boundaries.

—Tina M. Alberni

As with my other pieces, I layered paint and pattern. I began by writing the words "Beloved" and "Dearest" on paper, to create a first layer, embedding Catherine and Hyong's story in the process. In this collage I incorporated an illustration of a knight from a children's encyclopedia along with additional "knightly" text.

—Caroline C. Brown

— 58 & 59 —

YET, EVEN AS we grew as a family, it was clear who the knight was and who needed saving.

As Catherine thought about her life and the future after the kids were in school, she planned with the same meticulous precision she used planning three-week vacations.

She intended to work on sex trafficking issues with the U.S. Attorney's Office for the Western District of North Carolina—grand plans for a grand life. I thought this was heroic. She knew what she wanted and as challenging as sex trafficking is to stop, she wanted to stop it. Impossibly difficult, but a worthy ambition.

It turns out that her ambition extended beyond justice for all.

As she planned the epic road trip, she knew there would be times that we would be going over dirt roads and driving in the desert. She bought a Subaru Outback so that we would have four-wheel drive and a higher ground clearance. And when we got to those desert roads, *she* wanted to drive.

She drove around Monument Valley and across a scary dirt road that was prone to flooding (and oddly enough, it rained a lot while we were out there in the desert). ▼

Dearest,
You are my knight in shining armor,

tilting at the windmills,

following your
impossible dreams.
—Beloved

Beloved,
 This desert road
 is just dirt.

It looks dangerous,
 yet fun.

I'm driving.
 — Dearest

Beloved,
I thought it was the mountain heights,
but here at home, I still can't breathe.
Can I rest my head on your shoulder?
— Dearest

Dearest,
 It's a bad cold. Maybe bronchitis.
You'll get better; it's only a passing illness.
 Be glad it's not cancer.
 —Beloved

For the point in the story when Catherine's illness begins to emerge, I chose a scene with magnificent mountains rising to the sky.

For inspiration, I used a photo of a mountain in Alaska where I once taught a 12-day workshop. There were five glaciers across the bay, rising from sea level. I was there during the summer solstice and the light was virtually never-ending. (To sleep, I needed to pull the blackout curtains and wear a mask.) Moose hung out in the yard along with mating sandhill cranes that stood well over four feet.

I wanted the mountains to feel both impressive and joyful. I underpainted with pink to warm up the painting and to unify the piece.

Water takes up the bottom half of the canvas, symbolizing emotions and the unconscious. To me it also reflects uncertainty, saying, "Change is on its way."

And on the far right, a watery road leads to a house where a warm glow in the window shows that people are home; it's before dawn and they've been up all night. As the sun rises behind the mountains, it creates a field of rainbows. The ray of light hitting the land illuminates a small patch of green, a positive sign, hope for the future.

I enjoyed capturing the hopefulness of this painting, even knowing what was coming. This piece just flowed from the end of my brush; sometimes that happens. I step back and say, "Wow. I'm the only one in the room, so I must have done this."

—Diane Pike

WE ENDED OUR EPIC trip at 14,000 feet, in Rocky Mountain National Park. We didn't stay long on top of the mountain; it was cold, even in July, and Catherine had trouble breathing. The next day we were on our way home.

We thought the altitude was causing the problem and that she would feel better once we reached lower elevations. But even after we returned to Charlotte, she still had difficulty breathing. She would often have to rest after walking up the stairs or after doing anything that required any physical exertion.

Her illness lingered and worsened over time. We just thought it was a bad cold, maybe bronchitis. In a bid to be supportive and try to find a silver lining to her troubles, I said to her, "Be glad it's not cancer."

In retrospect, I regret those words because they turned out to be untrue. I just didn't know it yet. ▼

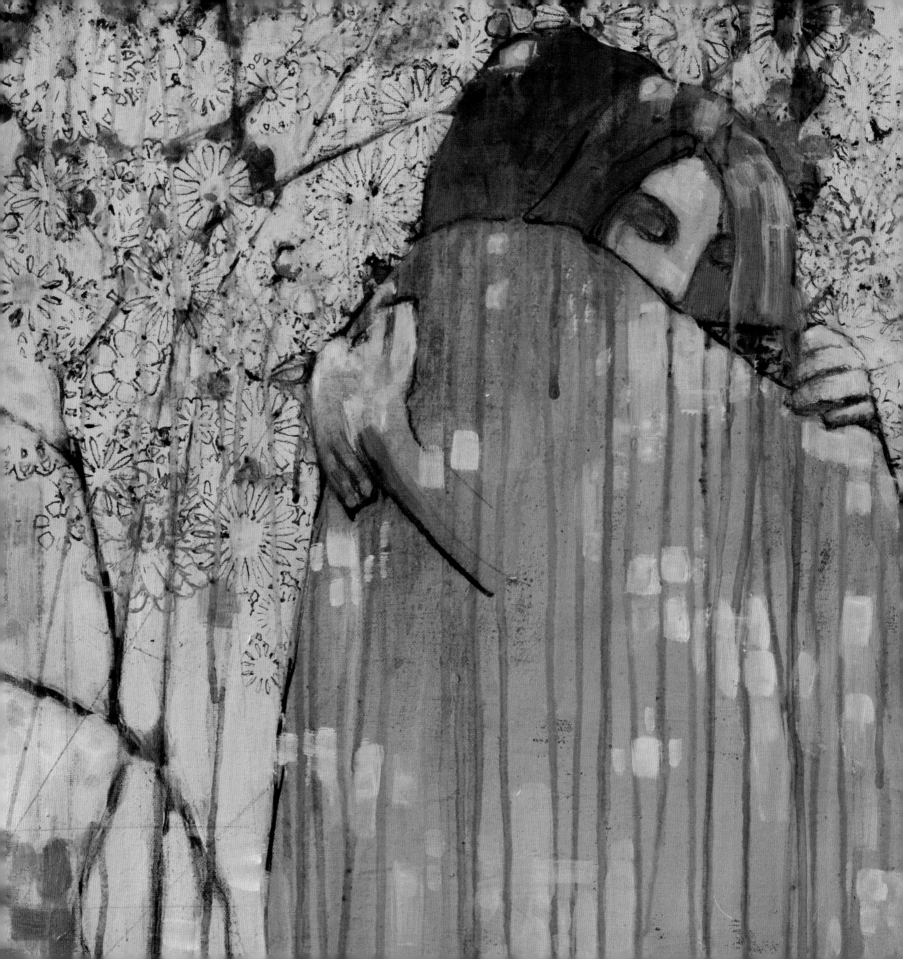

Beloved,
 I can't catch my breath.
 Help me up the stairs.
 You are my support.
 — Dearest

Dearest,
 I'm not going to work today.
I am with you as we figure this out.
Which hospital do you want to go to?
 —Beloved

EVENTUALLY, CATHERINE became too weak to make it up the stairs. I tried to make her life as easy as possible. I took on more responsibilities. I tried to support her as best as I could.

Finally, on a Monday morning, after several inconclusive urgent care visits and doctors' appointments, we went for x-rays. I drove because she didn't trust herself behind the wheel.

I thought it would be a simple thing—take her for an x-ray, drop her back at home, and then go to work. As it turned out, I wasn't going to go to work that Monday, nor the days that followed.

On the way home, her doctor called and immediately directed us to go to the emergency room. Not knowing how serious this was, we chose a hospital to deal with pneumonia, not cancer.

The x-ray showed that her lungs were being crushed by fluid building up in her lung sac. She had been powering her body off one-half of one lung.

At the emergency room, they drained all the fluid to relieve the pressure from her lungs.

Catherine passed out from the pain during the procedure. After flushing what appeared to be two gallons of fluid, they stopped and installed a drain to keep the fluid from building up again.

We knew we were in trouble, but it was still early and we had no idea how much trouble lie ahead. We scrambled to get help with the kids; we called her parents for reinforcements.

With each passing day, the news got worse.

"We think there might be some cancer in the fluid. We're testing it."

"There are cancer cells in the fluid. We need to do more tests."

"The tests show stage IV ovarian cancer."

"Hi. I'm one of the gynecologic cancer doctors at the hospital. Here's how we will approach this."

I stayed all week with her at the hospital, only returning home to shower, change clothes, and take the kids to school and daycare.

It was a most terrible week for this family that we were building.

The Embrace

I asked myself, what does support look like? I closed my eyes and tried to feel that embrace. These two figures exemplify "oneness." Together, they face something vague like the background.

This concept was so heavy—it needed a delicacy to it. The subtle dappling of light captures this tender moment. It is fragile, beautiful, delicate.

But everything has broken—I broke the stencil. Paint ran intentionally on this canvas; I cried and this fluidity with the paint mirrored my tears.

I finished, finger-cramped.

—Marianne Huebner

64

Beloved,
I went public with it last night.
Now everyone knows.
I'm afraid of how they will react.
— Dearest

Dearest,
I want to be strong for you so
I cry when you cannot see me,
in the car taking the children to school.
— Beloved

65

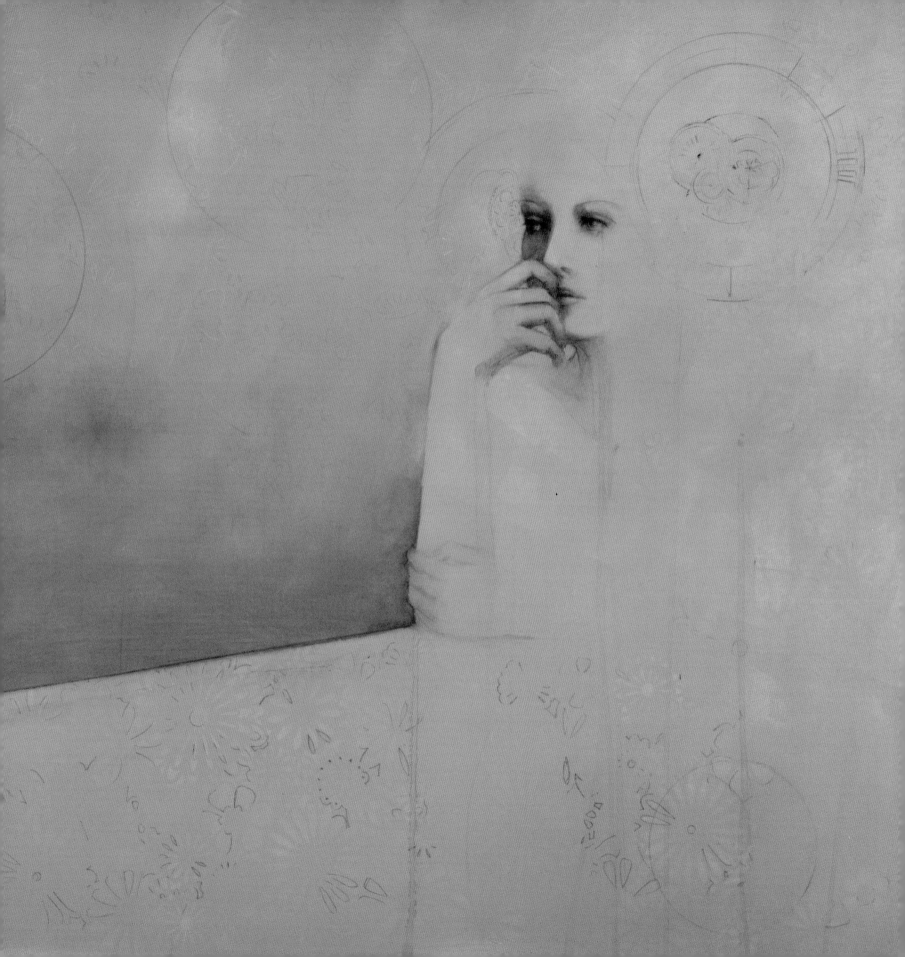

▲

ONE OF THE KEY issues we discussed early on was whether to keep this matter private or to go public.

Being the hero that she was, there was no question in her mind. We're doing this publicly. She wanted her fight with cancer to serve as a source of awareness for other women. She wanted even this to matter.

Being public servants, we drafted a press release—something we both understood. Even as we sent it, we were unsure how our friends and the community that we had become a part of would react.

I wanted to be strong for her. She was in a fight for her life and didn't need to expend energy on me. I cried every day for weeks. I'd take a shower, get the kids ready (Anna was seven and Alex was four), and drive them to school. I would cry silently while driving.

In their car seats behind me, they had no idea that something had gone seriously wrong with the life plan that we had been following.

Driving probably wasn't the safest time to shed tears, but in the car, Catherine couldn't see me.

140

Spaces Between Words

*Things are clearly disintegrating and their concept
of time begins to fall apart.
This is the moment they face the truth: Time is limited.*

*I can't imagine putting words to this
overwhelming feeling—the eternity of five seconds.*

*Tears fall—paint is running. Four layers of stencils
communicate the depth of their sadness.*

*Still, there is a white cloud of hope; like a grandmother's
tablecloth—it's fading; it's no longer solid.
The patterns are disappearing; time is disappearing.*

*Catherine looks toward the dark—the battle ahead.
This is where life meets death;
the awful dichotomy of hope and despair.*

—Marianne Huebner

Time Has Cold Hands

These notes were the hardest to visually capture. I know the desire of wanting more time. I understand how a lover's touch can alter reality. Yet, in the end, the very cogs of time cannot be ignored.

A tear falls from an eye as that truth sinks in. A figure in the red tower wishes to freeze the hands of time while a figure stands on the hand of a clock, constrained by time. Nearby, many hands of invisible clock-faces scatter like dandelion fluff after making a wish. These living greater-than and less-than symbols contrast great memories with having less than enough time to make more.

The bright tones from before are now soaked in shadow. A lonely world surrounds. The big gear symbolizes control; a finger touches a face with a tear knowing that time is passing all too quickly.

—Jonathan Grauel

– 66 & 67 –

A STRANGE THING happens when you realize that forever could happen much sooner than planned. We think about the past, the present—and the future that may never be.

For Catherine, it manifests in her wishing that we had met sooner. We met in 1999, when we were 26. We were each other's last first date of the Twentieth Century. She wished we'd met sooner so we could have more time together.

Not knowing how much time we had, but having researched stage IV ovarian cancer survival rates (she was that kind of person—a relentless and fearless researcher), she wanted us to be happy *right now* because that at least we knew we had.

My desires manifested differently. Like Don Quixote, Catherine was able to change other people's reality after she entered into their lives, just like she did mine. But this one time, I wished she had a different superpower—the ability to stop time so that we could live forever in the moment.

▼

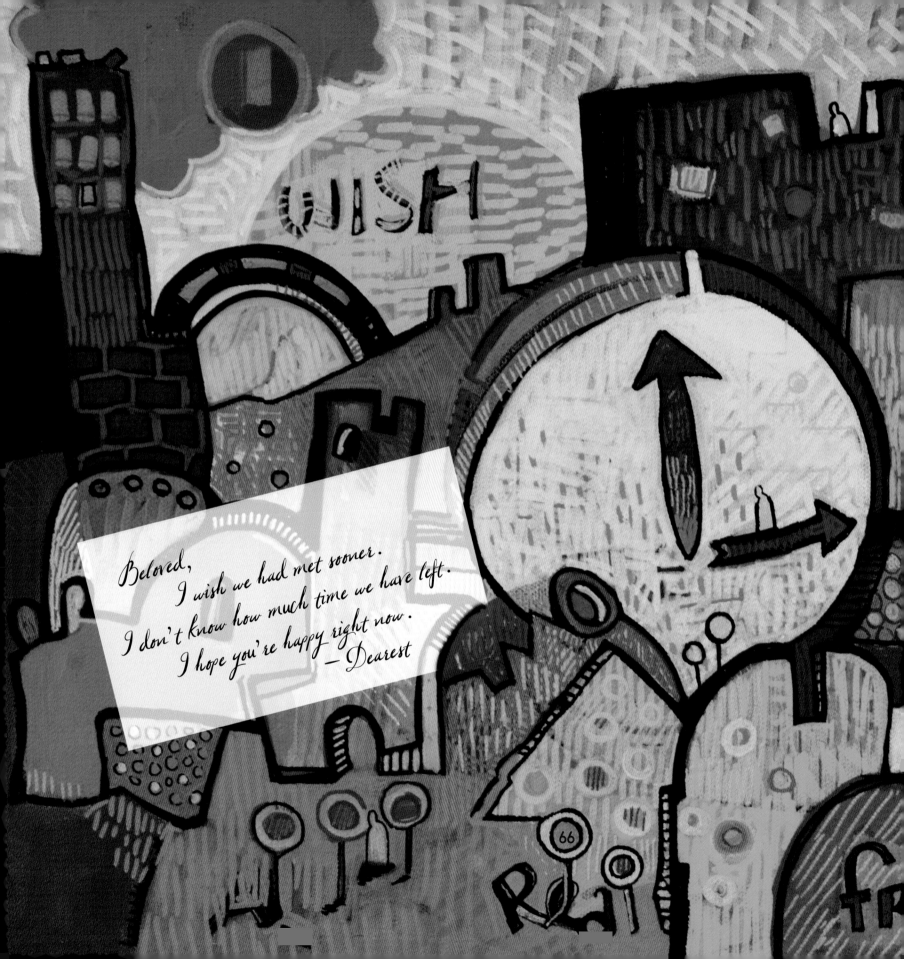

Dearest,
 Your superpowers alter
people's reality when you touch them,
but I wish your powers could stop time.
 —Beloved

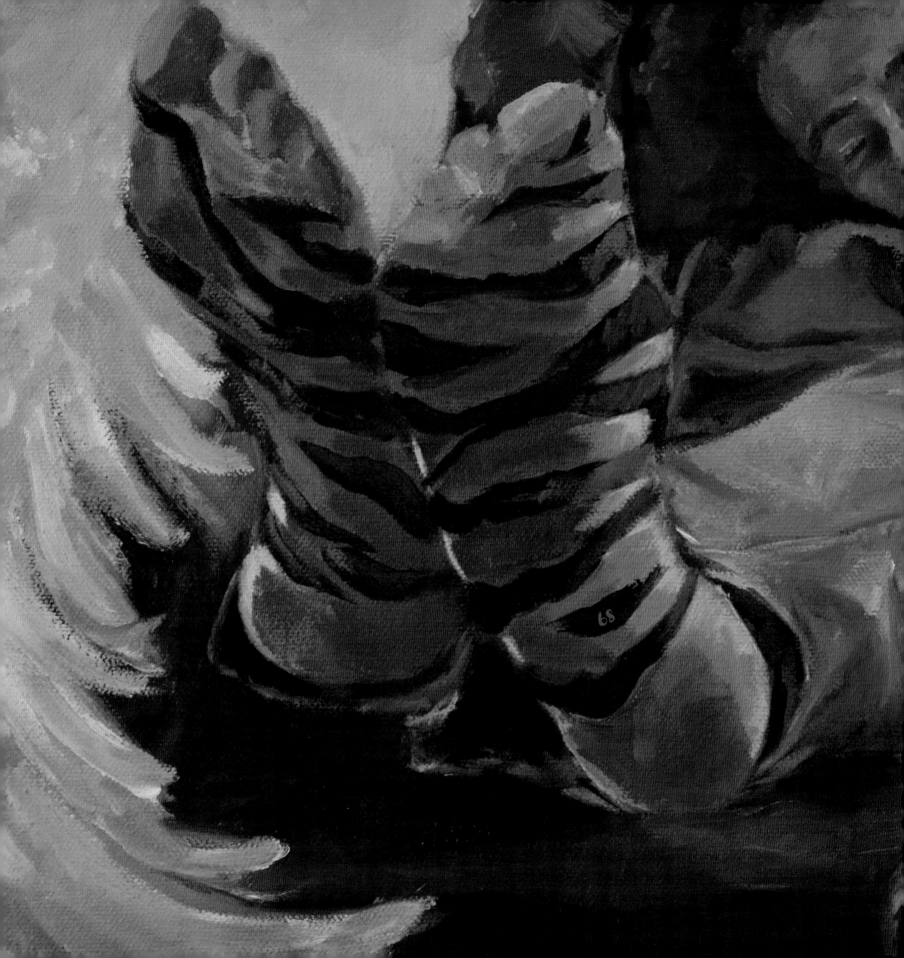

Beloved,
 So that you will never forget
your love and the mother of your children,
 I got you socks for life.
 — Dearest

The same character traits that allowed Catherine to meticulously plan a three-week vacation in the Southwest, also allowed her to start planning a future in which she wasn't present.

She set up a sock club subscription that sends me a new pair of colorful socks once a month. Each pair is accompanied by a note that reads, "So that you will never forget your love and the mother of your children." I will receive a pair of socks for the rest of my life, as long as the credit card remains valid. In addition, I get toilet paper, detergent, and foodstuffs for school lunches on a monthly basis through Amazon. She set all this up in advance so I wouldn't have to think about it. She knew I needed help.

For Heaven's Socks

At the beginning of this project, Hyong showed us his socks, and told us how Catherine made sure he would receive a pair of socks every month for the rest of his life.

I thought, "What a genius idea. Socks are such an intimate and necessary article of clothing. And yet, they aren't so intimate that if he ever found someone else to love, she would object."

He said he threw his old socks away, showing a willingness to let this reminder of her be with him every day. It makes my cry imagining him choosing a pair of socks each morning.

His socks are bright and colorful and happy. It's as if she's saying, "Remember me, but be happy, let the colors and joys of our life together anchor you, be your base and comfort you." Every day, he stands on a loving reminder.

Here I painted a pair of orange and blue socks (for UVA) with a tiger pattern to denote strength because it is hard to be both mom and dad now. I pictured him exhausted at the end of the day, with his feet up on the ottoman. And she's there; her wings enfolding him. He is wrapped up in love.

—Laura McRae Hitchcock

My approach to the world's problems is what I called the Soviet Method. Back in the day, as they prepared to battle NATO, what the Soviet Union lacked in quality, they made up for in quantity.

I figured that if I just put in enough effort, I could overcome any obstacle, problem, challenge, endeavor that I put my mind to. I've done this with home renovation projects, outdoor projects, and other tasks assigned to me by (household) management.

However, in this one instance, no matter the effort or determination with which I approached our cancer problem, I couldn't fix it. I was a bystander to the battle taking place in Catherine's body and the resources that the doctors marshalled to combat it. All I could do was support her and be hopeful that something would work.

When your own body is trying to kill you, and you know you're running out of medical options, it is difficult to think that you have control over anything. To gain some control over what was left of her life, Catherine started thinking about her death. We did what we called the Greater Charlotte Cemetery Tour. We drove around several counties looking at various cemetery options to see if any were suitable. It was the saddest tour we've ever undertaken. Ultimately, she decided on being cremated and interred at the columbarium at St. Peter's Catholic Church in Charlotte. It's our home church and makes visiting her easy.

She also planned her entire funeral. She picked the funeral home, the coffin, the music, the readings—just about everything. All I had to do is show up.

Just as I had my "acts of love" to show her how I felt, she had hers to show me the same. ▼

These notes evoke our fragile existence and how little we think about it. After two essential cells become one, Nature creates a big bang similar to the one that began the universe. In this sense, every creature is its own micro-cosmos. At that moment, Nature opens its hands and a being soars forth. The hands of nature both open and close. They are like both a uterus and a coffin.

Last year, I received a serious medical prognosis. Soon, brochures began to arrive by mail and email from funeral institutions and insurance companies. At first, insulted, I threw them into the trash or marked them as spam.

In my head, the event those brochures presaged could not happen NOW. A lot of time must pass before that would be a reality. Soon though, symptoms began to appear; things I wasn't expecting are crossing into my everyday life. I am not so confident that a large period of time is, for sure, still in my pocket.

I have faith that life will give me the opportunity to see my children grow, but I am wise enough to recognize that time is something we never really have for certain.

When you're at this stage, you are in a place you never imagined. It is a matter of love as Catherine said, to think and take care of ourselves and to plan things when we still can.

Nature closes its hands and that is the end of the journey on this dimension, but the beginning of a new one somewhere else. You belong to the earth; you return to the earth. The crane flies away to another place; another nest. Our souls go on to a better place.

I believe that.

—Luis G. Ardila

Dearest,
 With sheer effort and will,
 I can fix most everything.
 I cannot fix you, but I hope.
 —Beloved

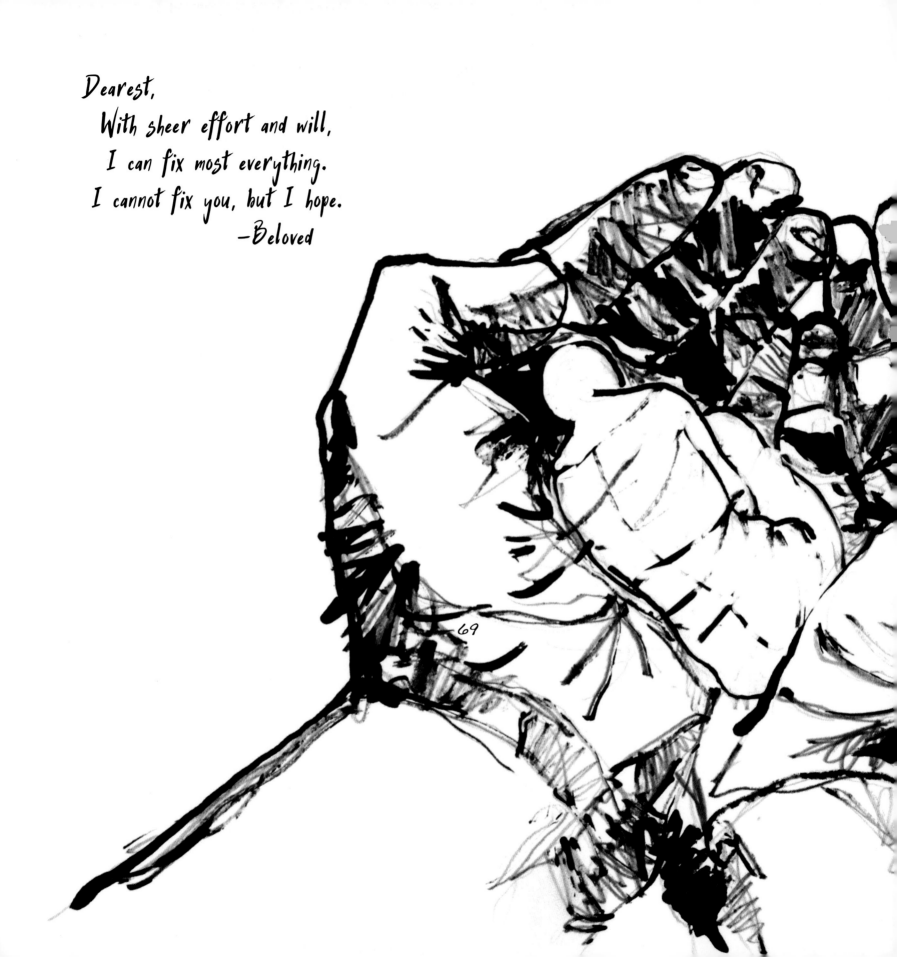

Beloved,
To gain control over my life,
I have planned my funeral and burial.
This is how I love you.
— Dearest

Dearest,

I see the beautiful
scars you carry

from all the surgeries
in your warrior's

crusade to win
your life.

—Beloved

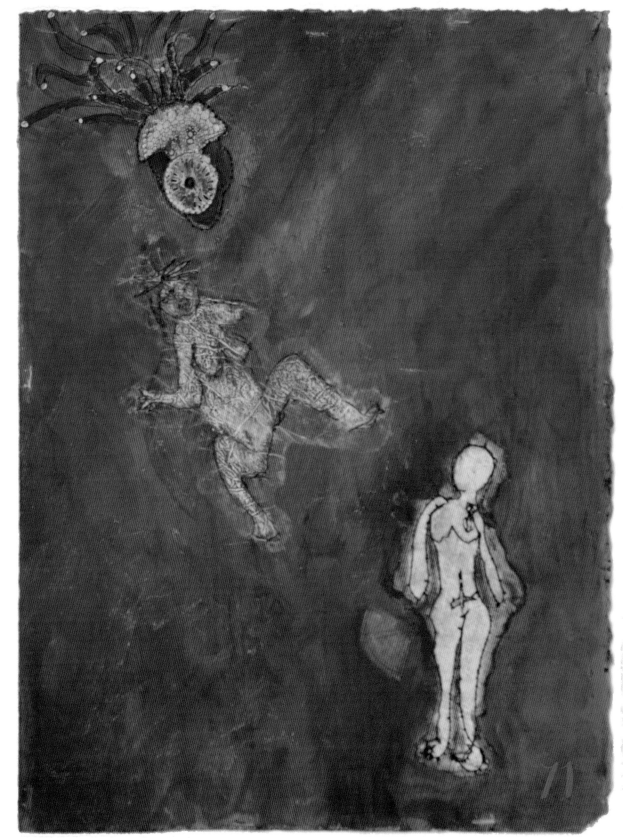

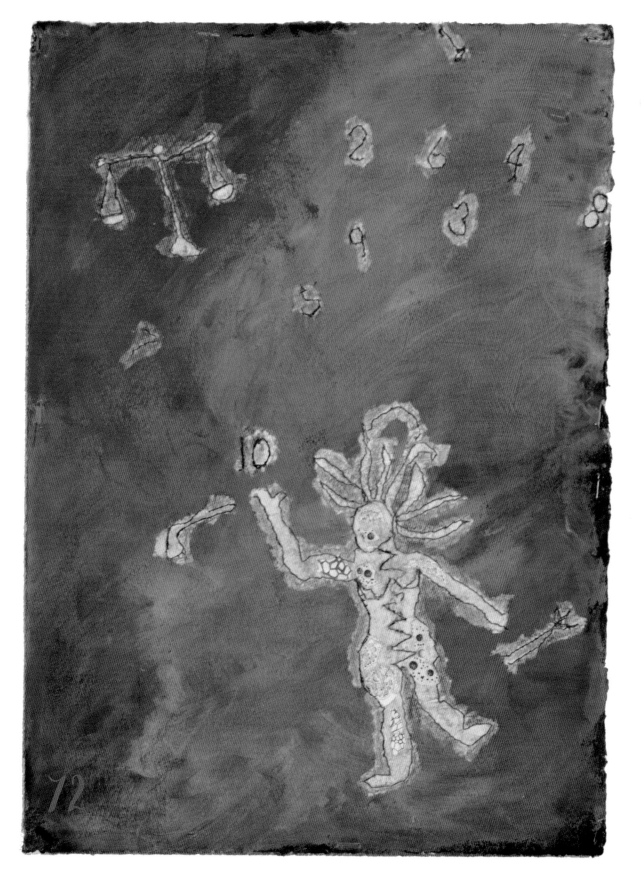

Beloved,

I'm tired and in so
much pain.

I know the drugs are
not working.

I have no strength to
fight and I'm
scared.

— Dearest

A war metaphor seems too easy a reference when talking about cancer, but in reality, a war is an apt description. With each surgery or medical procedure, the number of scars grew. One in her chest for the placement of the powerport for chemotherapy infusions. Several on her abdomen for the surgeries to remove the cancerous parts of her gut.

There are very few visible outward indications that there's a war taking place in her body. All that passersby saw to indicate that Catherine was a cancer patient was the short hair, the wig, or the hat that she would wear. It is only in the most intimate settings that the scars of war are visible and you realize how strong a warrior Catherine—and every cancer patient—is.

However, war does take a toll. With each drug failure and the accompanying side effects, she got weaker. She endured so much pain to win her war. One particularly horrendous side effect made it feel as if glass shards were caught in her throat.

She also knew that the treatments were not working. She had read up on ovarian cancer research, making herself one of the most knowledgeable laypeople on the current state of research—both drugs and trials. After enduring a year of failure, she was scared.

When I received my notes, at first I was frightened by them. Sometimes, I just had to leave my studio; I had to walk away for a few days.

The sewn figures allude to the stitching that follows multiple invasive surgeries. The figures become more split and torn, in the way the physical and emotional being becomes divided, between the will to live and the need for release from pain.

Images of Catherine as warrior suggest the tearing of flesh from spirit. She is now in a realm where pain and reality become too difficult to experience in any "understandable" way.

I am a cancer survivor, but I did no work based on my personal experience. I didn't really want to look at it—the time frame when you're living in your body, but you're not really there. With cancer, you exist elsewhere, realizing things are changing; you're changing.

Here, red means pain. The green object represents where your head is; to continue with life, you must separate your physical body from your spirit. Leaving is an option.

The scales represent many things—where is the justice of this happening to her?

The numbers are my attempt to illustrate the "On a scale of 1-10, how bad is your pain?" question. It strikes me as such a stupid thing to ask. There is no way to measure this pain.

—Rebecca Haworth

– 73 –

Catherine asked me to make her
1,000 paper cranes.

The maker of 1,000 cranes
gets a wish from the universe.

I started with optimism during
her first chemotherapy treatment
(it took eight hours)
and diligently made my cranes
sitting beside her
as she was filled with drugs.

I wanted to give her the wish
that she wanted for herself.

▼

153

While undergoing treatment, patients and caregivers often create artwork as an outlet and temporary "vacation" from cancer. I was artist-in-residence at the center where Catherine received her chemotherapy infusions.

In my role there, I witnessed how the repetition of marks, colors, or activities seemed to bring comfort. Personally, I perceived this repetition as an attempt to create order and find harmony amidst chaos.

I can only imagine the satisfaction derived from the repetitive folding required to make 1,000 paper cranes.

I sought to bring this sense of repetition and rhythm to the pair of paintings which illustrate Note #73. Making them airborne shows Hyong's "wish" being sent into the universe.

—Jean Cauthen

Dearest, I fold one thousand paper cranes

so that the universe will grant you the wish

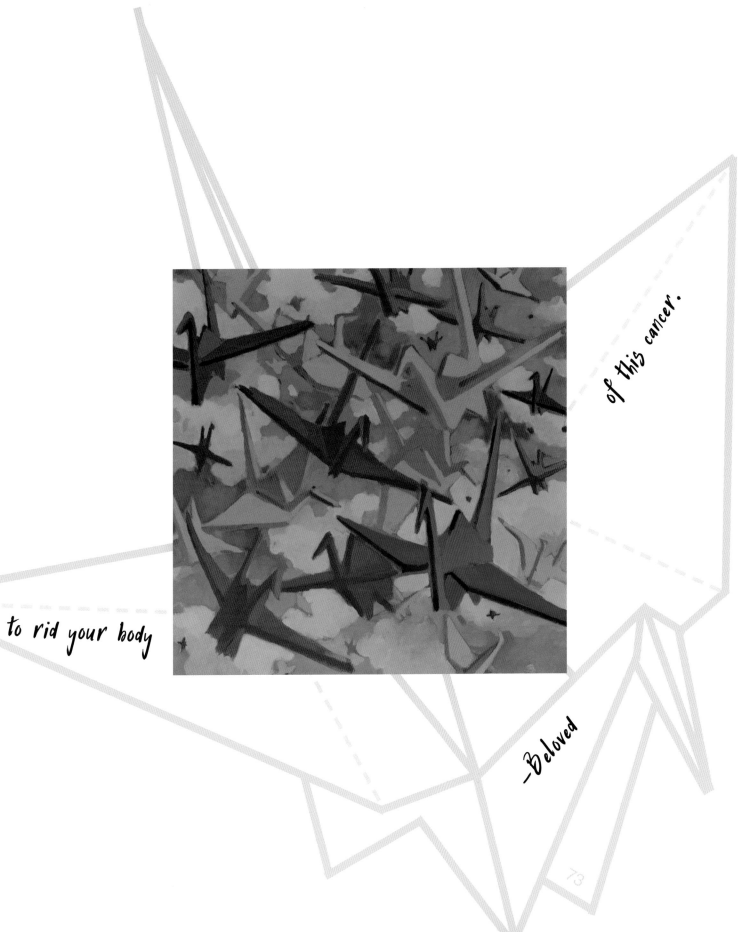

to rid your body

of this cancer.

—Beloved

Beloved,

 I'm afraid of being forgotten.
 With time, you'll move on and forget me.
 I'll be nothing more than a memory. — Dearest

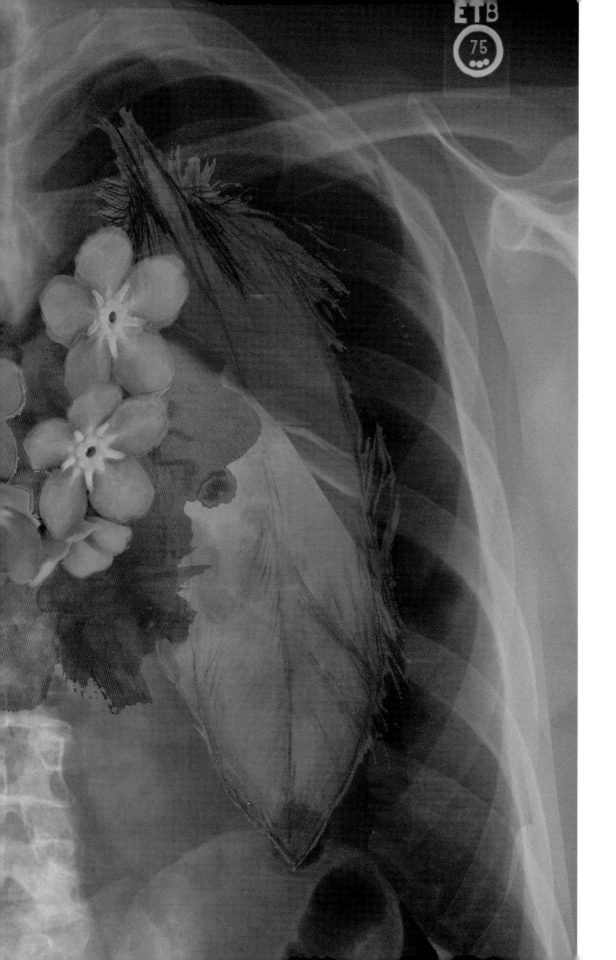

Dearest,

Hold still. I have to drain fluid from your chest.
It's with the greatest love that I cause you pain.
I want you to breathe. I want you to live.

—Beloved

▲

— 74 & 75 —

Catherine was afraid not just about dying,
but also about being forgotten.
Being young when you get cancer means
that you can think about
how your spouse and your children
will live life without you.

She didn't want to be just a memory
or a headstone.
She wanted us to remember her
and to leave an indelible mark on our lives.

My job shifted over time
from cancer support to cancer care.
The fluid building up in her chest
required a permanent drain be installed.

It became my job to drain the fluid
so she could breathe.
It was a painful procedure, but necessary.
I wanted her to live
and that required breathing.
This meant draining
one to one and a half liters of fluid
every few days.

When I read through this note the first time I knew this art would be my biggest challenge both emotionally and artistically. How could I represent such a painful memory? I was so distracted while imagining how much pressure the fluid created in her chest and around her heart, I began to wish that her lungs would feel as light as feathers when the fluid was drained.

—CeCe Stronach

CeCe's colored pencil drawings became almost other worldy when overlayed with x-rays: Reality and the ethereal, fused.

There is so much conflict in this pair of notes. Catherine, always looking ahead, focuses on what lies beyond; Hyong, on the other hand, must pay attention to the here and now, and is forced to be practical. He struggles to keep her among the living even as she fades away.

My youngest child is a cancer survivor, and these notes summon the memories of caregiving—some still the stuff of nightmares—multiple medications and their complicated schedules; many hours spent in surgical waiting room; administering IV drugs at home. The responsibility and the consequences of failure were overwhelming. If I had stopped to recognize what I was actually doing, I would not have been able to continue.

Now Catherine's heart, no longer a gentle pink, is a full blown rose, ready to drop its petals. With the rose rests a small cluster of delicate flowers, her deepest desire now—forget me not.

—Avery Caswell

WE OFTEN DISCUSSED whether it was better to die quickly, for example in a car accident or from a heart attack, or to die from a prolonged illness, like cancer. There are advantages and disadvantages to both.

A quick death means no sustained suffering for the dying person, but it leaves those remaining to pick up the pieces and make sense of it all.

A prolonged illness means that there's time to put affairs in order and see loved ones, but it can put an emotional and financial strain on those who love the dying and on the caregivers.

We concluded that there is no right answer, just different ways to die. You have to be ready to take advantage of whatever silver lining death affords you.

In Catherine's case, she had the opportunity to leave behind a legacy for the children. She started working on an art journal with a local artist to give to the children. She also had two quilts and two teddy bears made from t-shirts that had been important to her. In the bears are recordings of her voice offering words of comfort for those moments of heartache that require a mother's reassurance. "I love you. I will always be with you. I will always be your mom. I am giving you a big bear hug."

I've often wondered if I could have endured what Catherine went through. I hope to never find out.

I do know that I couldn't have been prouder of her for enduring the treatments (and their side effects) so that she could have as much time with her children as possible. It was an impossibly heavy burden to bear, but she did it with grace. ▼

Under Cover

The items mentioned in these notes are primarily for the children, and denote comfort and companionship.

Catherine looked into the darkness, and instead of letting fear take over, she looked to the future and made places in her children's hearts where her love for them could remain, safe and real.

The lantern signifies that Catherine and her love are present, glowing around them. "You can't see me, but don't be afraid. I'm still with you. Even when you're sad or feel alone in the dark."

That she made tangible things for her children even as she bore this terrible burden is the very definition of courage and strength.

—Laura McRae Hitchcock

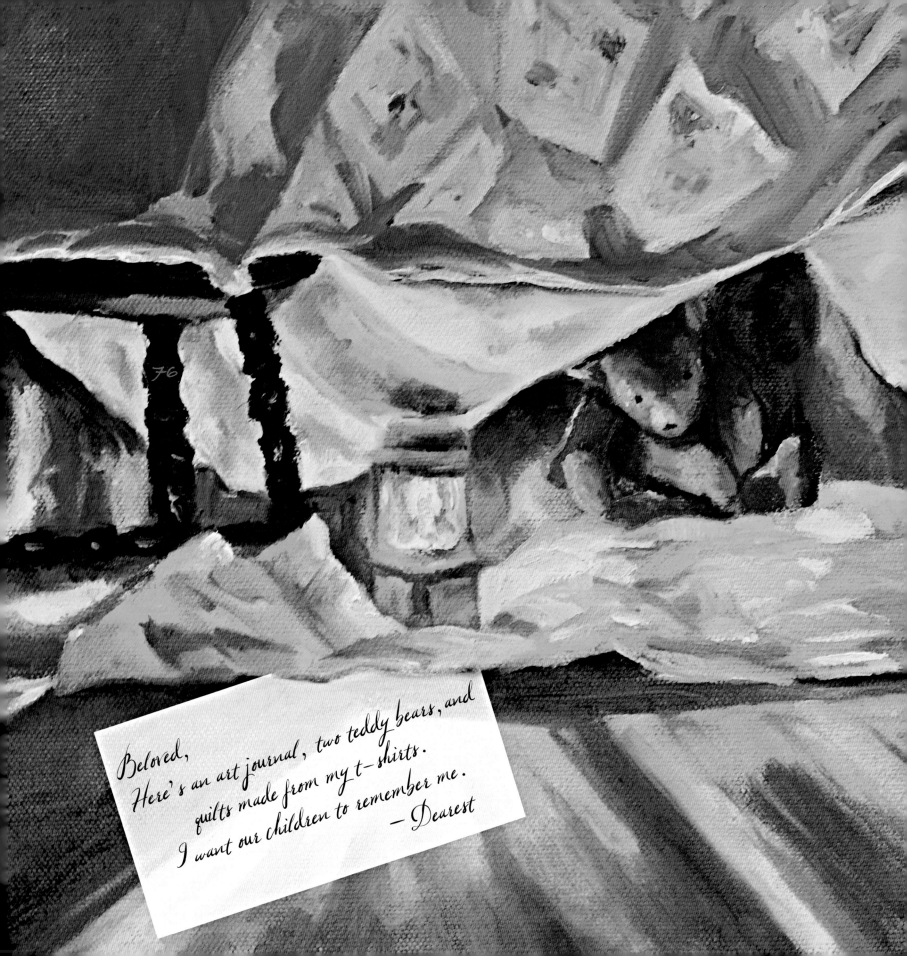

Beloved,
Here's an art journal, two teddy bears, and
quilts made from my t-shirts.
I want our children to remember me.
— Dearest

Dearest,
I am so proud of you
for the courage with which
you bear your burden.
—Beloved

YET, THERE WERE moments when even Catherine succumbed to the realization that there was no magic bullet. She knew she wasn't going to win, and it was devastating.

It also made her angry at life's unfairness. "Why me?" she would cry into the pillow. Relatively speaking, very few women under 40 years of age get ovarian cancer and with no history of cancer in the family, this just seemed so unfair. She wasn't ready to die, but we were running out of alternatives for treatment.

One of the most amazing realizations during this time was how powerful a community can be when it decides to mobilize. So many people in our neighborhood, civic affiliations, friends, family, and strangers from around the world were supporting us—financially, spiritually, and in person—and I still benefit from that support today.

In the beginning, they helped with the kids. At times, the community knew more about their whereabouts than I did. Towards the end, they helped by keeping Catherine company—visiting, rubbing her feet, staying nearby to help take care of her and cook for her.

To all the members of the community, who loved this family, I am grateful for their support. Without them, we would not have made it. ▼

My last pair of love notes spoke most deeply to me: In the face of frustration, desperation, and despair, Hyong and Catherine are held in the arms of their community. I collaged prayers on pages from the Episcopal Book of Common Prayer. The "Prayers of the People" are contained in the image of a dove, God's Holy Spirit. Prayers of healing, prayers of comfort, and prayers of solace break through the darkness of Catherine's cancer.

I am glad to have met Catherine when she took a liking to one of my mixed media paintings. In it was an image of a young woman in cat's eye sunglasses, smiling like she's on top of the world. It was the same smile that Catherine wore to my visual journaling classes as she painted and wrote pages for her children. It has been an honor for me to know Catherine and Hyong, to share a small part of their journey, and to contribute my art to their heartfelt love notes.

—Catherine C. Brown

Beloved,
 I'm not going to beat this!
 I'm devastated and angry!
 I'm not ready to die!
 —Dearest

Dearest,
 See the community gather.
They rise up to protect and comfort you.
 Their love for you abounds.
 —Beloved

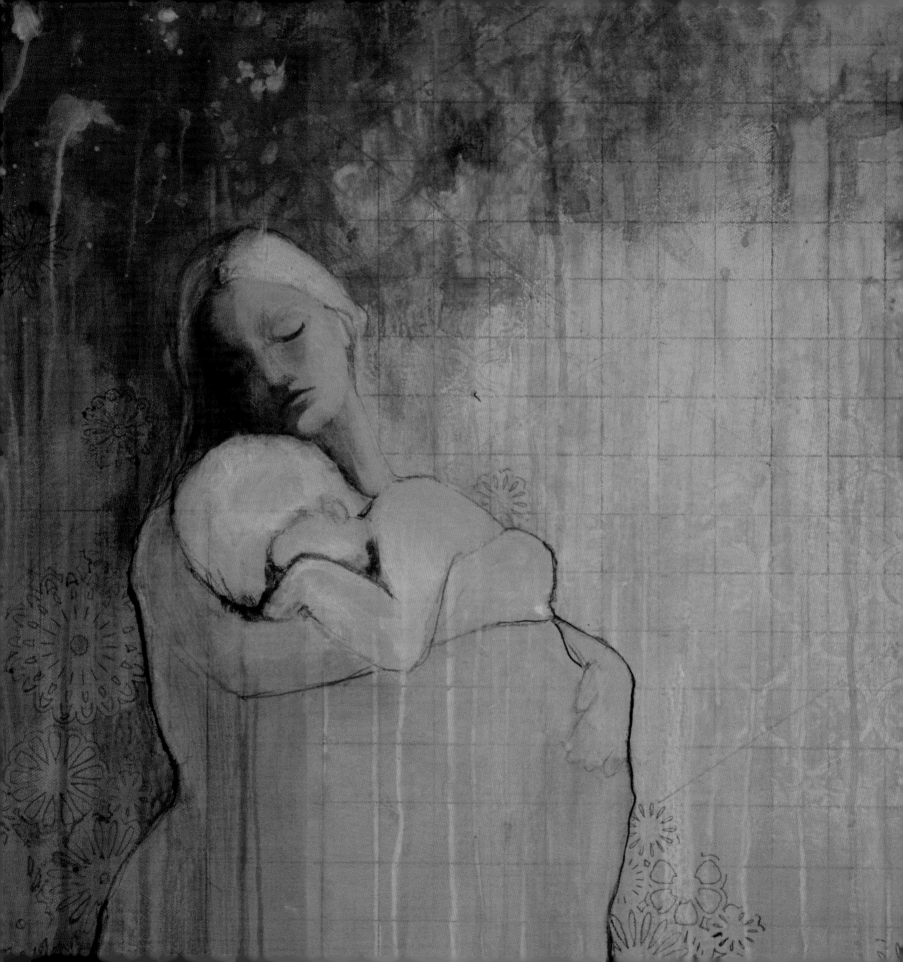

Beloved,

Our children need
a mother.

I am heartbroken that
it won't be me.

Honor my memory
when I am gone.

— Dearest

80
81

Dearest,
I don't want this life
without you.

You are my center
of gravity.

The future flies
apart without
you here.

—Beloved

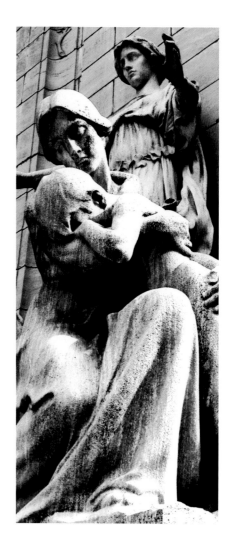

— 80 —
Maybe things would not have been so sad
if we didn't have such young children.
Anna was seven and Alex four
when Catherine was diagnosed.
Catherine would often exclaim that
our children needed a mother.
She was so sad that it wouldn't be her.
In many ways, this realization was worse
than knowing she was going to die.
She loved her children.
She hoped, but had no illusions,
that both children would remember her
after she was gone.

— 81 —
Even I started to accept
that our time together
would not last much longer.
The idea of living life without Catherine
was unfathomable.
She was the gravity holding
everything together, especially
the future which she had planned for us.
Without her, it all flew apart
and the future became uncertain.

Mother's Love

This was the hardest piece for me to paint. It plunged me into the vulnerability of being a parent and touched on my "mother-ness."

Thinking of that moment—how do you let go? This is the last hug I'm going to give you. It was too sad, imagining this.

So I began with grid; the grid equalled stability, and became a net that catches. I needed some predictable structure to allow me to explore further. Then I added a background with ethereal, dappled light. I used stencils to indicate that life goes on. There are flowers, and light. The void, fill it in as you will.

But what was the image? I couldn't see it. During a quick weekend trip to New York, I walked past this statue in Central Park—a huge angel standing behind a mother and child. The child's head is buried against the mother. These figures merged with tears, more running paint—not always tears of sorrow, but of love— completed the piece.

—Marianne Huebner

— 82 —

In the beginning of our fight, when hope still lived,
Catherine was very clear about how she felt about
me getting remarried if she died.

She didn't want to be replaced by someone who
would get more time with me than she'd had.

I knew her thinking about the future was changing
when her position on me remarrying changed.

One day she told me that she would be okay
if I got remarried. I deserved to find love again
and not spend the rest of my life alone.

▼

It was important to capture the tone and timing of this love note.
They move together. He is supporting her, guiding her.
Her body idles between mobility and rest.

—Nick Napoletano

Beloved, I hope you continue to dance

by yourself or with someone else.

You have my permission to find love again. — Dearest

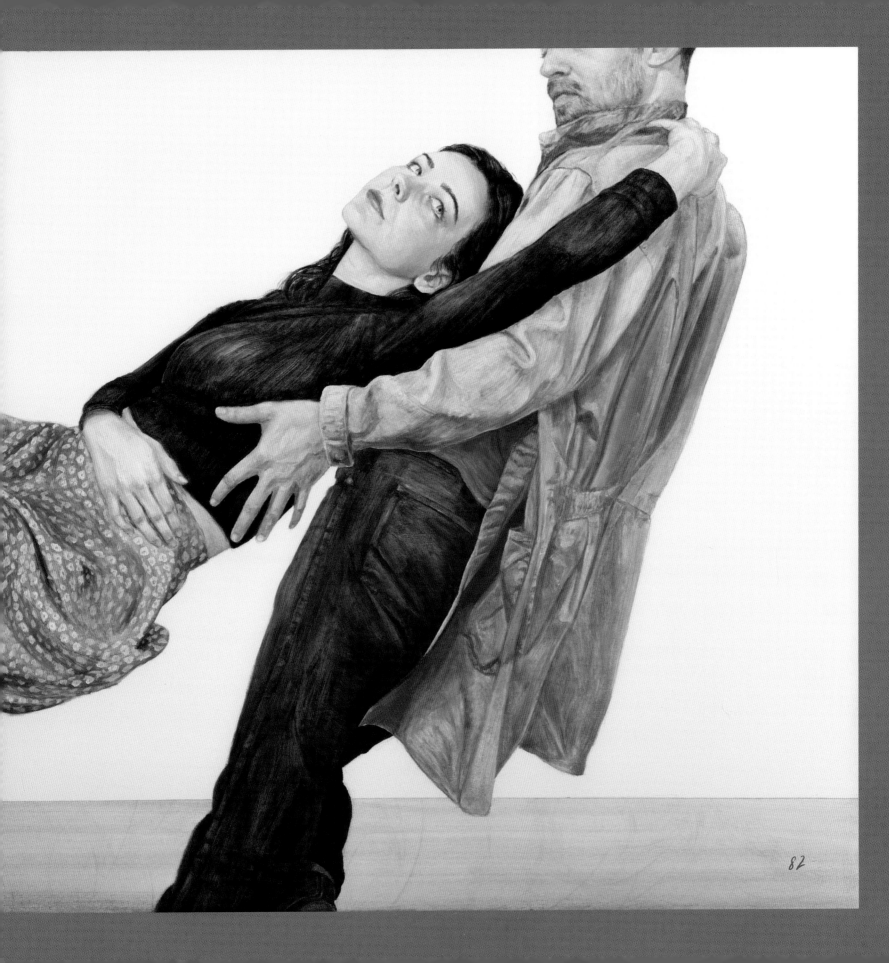

82

— 83— On November 20th we made our regular visit to a clinic specializing in experimental treatments. After reviewing the MRI from the previous day, the doctor told us that in the two-week period since our last visit, the cancer was winning. There was nothing else he could do. He recommended we contact hospice and make arrangements for a comfortable end. Devastating news.

In retrospect, I shouldn't have been surprised. Catherine had been taking increasingly frequent doses of a very strong narcotic to deaden her pain. She wasn't eating much. She also slept a lot—all signs that her body was struggling. I didn't know what these signs meant until someone explained them to me.

We went home and I got her comfortable on the sofa. (The previous day, she had been so weak that we had trouble getting down the stairs. There was no way we were going back upstairs.) The living room had become our new bedroom. I slept beside her on an air mattress in case she needed anything. We waited for the ambulance to take her to hospice. They finally arrived around 8 p.m.

Two things stick out for me about this experience. First, the children asked how we were going to celebrate Christmas if their mother was in the hospital. I told Anna and Alex that we would celebrate early with Mom at the hospital. Anna's eyes got real big and she exclaimed, "You can celebrate Christmas early?! You can do that?" It was a revelation to her that celebrating early was even permissible. It was a moment of levity in an otherwise incredibly depressing day.

Second, Catherine slept pretty much the entire time waiting for the ambulance. It was a sign that her body was conserving energy for vital functions. I woke her to tell her that the ambulance was here. As they took her I said to her, "I love you." This was the last thing I ever said to her that she acknowledged.

— 84 — "I love you too," she replied. I didn't know it at the time, but these would be the last words she ever said to me. Speaking wasn't a vital function and her body was conserving strength to keep her organs running. These last words would have to carry me forever. ▼

HeartSpill

This small mosaic bears a long history of tormenting its maker, having been completed and destroyed three times. When I read the note in our first meeting, I immediately thought, "No No No No." I know too well the coming of the ambulance, the mix of trust and welcome and agony and knowing and the unwillingness to let go, the ripping of the heart. HeartSpill is a mixture of precious materials: Hand-poured Italian and Mexican glass and gold. The image symbolizes day into night, with red for both the ambulance and the forming and breaking of a heart at this moment of profound loss. The tiny gold heart, of course, remains, but it will take time to focus on the ever-love; the long spilling is a necessary part of the path.

—Pam Goode

Dearest,

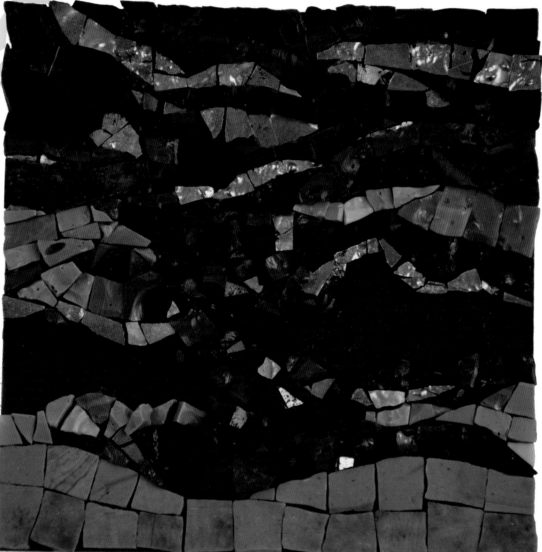

—Beloved

Wake up. It's time to go.
The ambulance is here.
"I love you."

"I love you, too."

I have no more strength to talk.

Carry these last words forever.

Beloved,

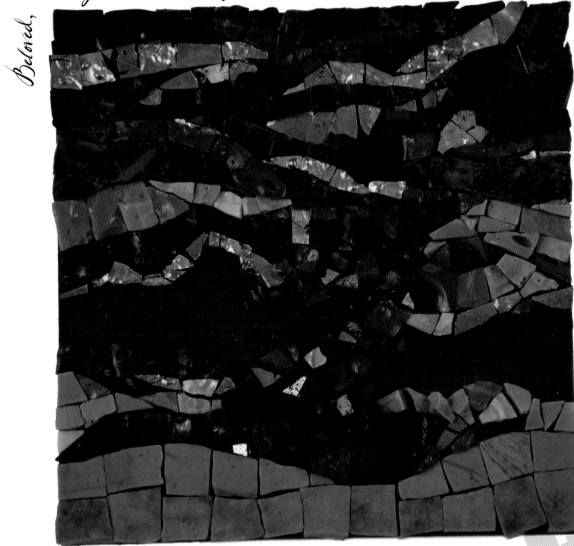

—Dearest

84

Dearest,
You, in darkness, falling into grace.
I'll keep watch through the night,
holding your hand as you sleep.
 —Beloved

▲

AS WE SETTLED in at hospice, the nurse made Catherine comfortable and suggested I go home and come back in the morning. So I went home, believing we would have time to celebrate the holidays and rethinking how we would do that in a hospice room. I received a call at 1 a.m. from the nurse telling me that Catherine wasn't stabilizing and that I should return.

So I did.

I spent the rest of night holding her hand and talking to her. I recounted memorable moments from our past, the state of our present, and hopes for the future. I talked about Anna and Alex. I whispered my regrets about what would never be. I promised I would keep watch through the night. I maintained my vigil with spoken words for four hours. I'd never spoken this long to Catherine uninterrupted. It was a first, but for the best of reasons.

At this point, there are no more words from Catherine. I can only imagine what she would say if she could.

I imagine that she would have assessed our time together as a positive thing. I am privileged that she found happiness with me. While there were ups and downs, calm seas and rough ones, our time together was memorable. Shortly, however, there would only be one of us left to navigate alone.

As I contemplated how to represent this pair of notes, I received inspiration from a friend who said people's lives pass before them at the end.

I included elements from most of the 100 notes to symbolize not only Catherine's life passing before them, but also the memories that Hyong would continue to carry with him. I asked the other artists, Can I paint your sock, your four-leaf clover, your cherry blossom?

On the right, Hyong holds his wife as she begins her transition, their life together replaying as her spirit, portrayed by the lone duck, moves toward the angel on the left. Her spirit (in white wisps) moves toward peace. The angel sends strength in teal (the color for ovarian cancer awareness) towards him.

Although the sea is turbulent, the little duck, Catherine's spirit, swims on its own toward the foot of the angel who is accompanied by the archetypal symbol of strength, the lion.

Catherine's hand is in his, but hers is disappearing. And this is the hardest part, this is Catherine's soul, leaving the stormy sea of her sickness. She's slipping away, moving on.

—Emily T. Andress

Beloved,
This is where I leave you.
There are no more tomorrows for us.
It is the heartbreak of a lifetime.
— Dearest

88

Beloved,
I found happiness with you.

I adored every minute together.
Now live for us both.
— Dearest

▲

My monologue continued into the early morning
hours. I lay down beside Catherine on the
rollaway bed. I had put it as close to her as I
could. Holding her hand, I continued to talk to
her about all the things that I had put off.
I told her, "I will never let go."

As much as I wanted to hold on,
Catherine was ready to go.
There would be no more tomorrows.
How could this not be the
greatest heartbreak of a lifetime.

This is Where I Leave You

When my mother passed, my sister was at her side. A tribal chief told her, "Your mother is preparing for a big journey. She is ready to go. You need to let go."

Here, Hyong must let go, though it literally breaks his heart to do so. The line of paper hearts echoes the line of the prayer flags in Notes 34 and 35. The chains are broken as Catherine is pulled into the darkness. He's leaning in, holding on.

Though this is incredibly sad, there is a sense of peace .

There is a sweet miracle in this story and in these notes. I could not help but hold my dear ones closer, send love notes to my beloved, and reach out to my darlings far away.

My gratitude for their very existence grew by multiples. Every day with them becomes ever more precious.

Until they say to me, "This is where I leave you," we will hold each other close.

—Jen Walls

If there is one love note among the 100 that grabs very deep inside me, it is number 89.

When my mother reached her 90's and could no longer live on her own, a nursing home didn't seem like the right option. Instead, she lived with me during her last years. We had our routine, preparing her breakfast, sitting with her while she ate, etc. It was not a hard thing to do every day. I knew when the end drew near, but didn't realize how imminent it was.

The day she passed away, I heard her get up and then return to bed. I fell back asleep and dreamed that I saw her. She was trying to tell me something again and again, but I couldn't understand her; she kissed me and then flew away.

I woke up a little later, following our usual routine and making her breakfast. I called her; no response; I called her again, then touched her cheek and knew she was dead.

After I called 911, they took her to the morgue. I hadn't said good-bye; the Catholic tradition of anointing her, so important to me, was left undone .

Reading Hyong's poem touched me so deeply; maybe these were the words my mother had tried to tell me in my dream. I felt pardoned; I was absolved. It was the greatest thing to no longer feel guilty.

—Luis G. Ardila

— 89 —
The nurse woke me at 6:30 a.m.
I had fallen asleep around 5:30 a.m., and in that hour,
Catherine had passed.
I had failed to keep my promise
of watching through the night.
I carried a lot of guilt
from not being with her until the end.

— 90 —
About a month later, I shared how I was feeling online via
Facebook. There were many stories similar to mine
about how the dying wait to leave until the living fall asleep.
This was their way—even if unconscious—
of protecting the living from the burden of seeing death.

Even at the end, Catherine shared an act of love.

This is how she loved me.

▼

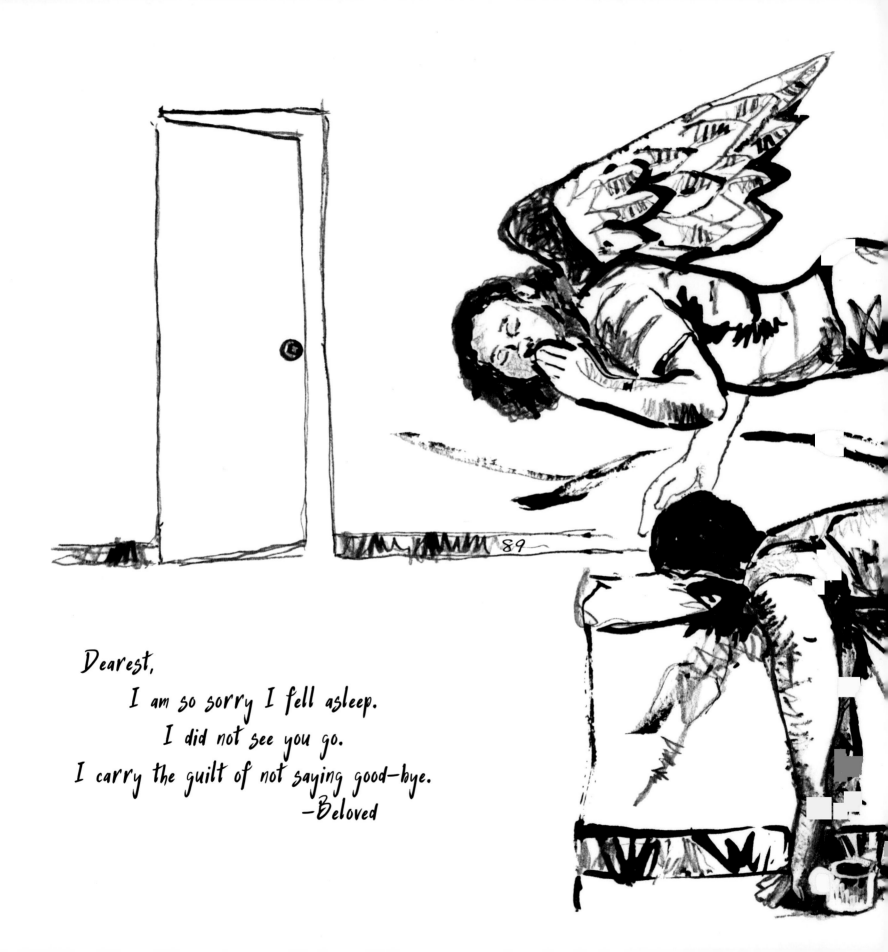

Dearest,
 I am so sorry I fell asleep.
 I did not see you go.
I carry the guilt of not saying good-bye.
 —Beloved

Beloved,
 Hold your head high.
 Be proud. No woman could have asked for more.
 I left while you slept to ease your burden.
 — Dearest

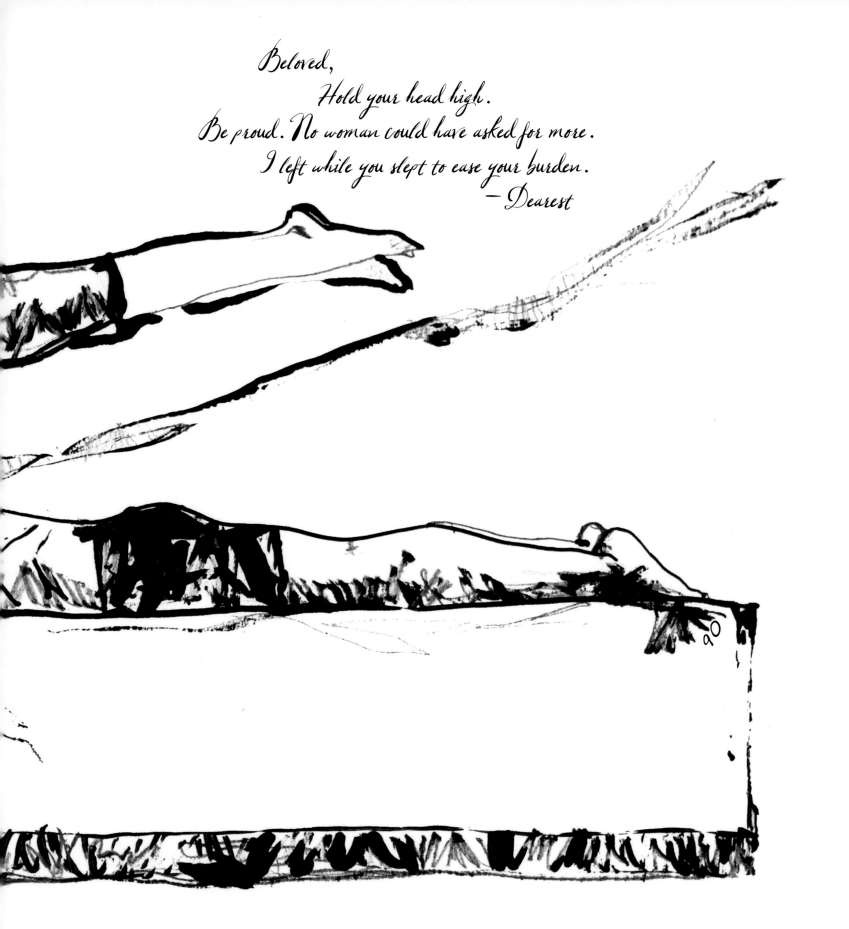

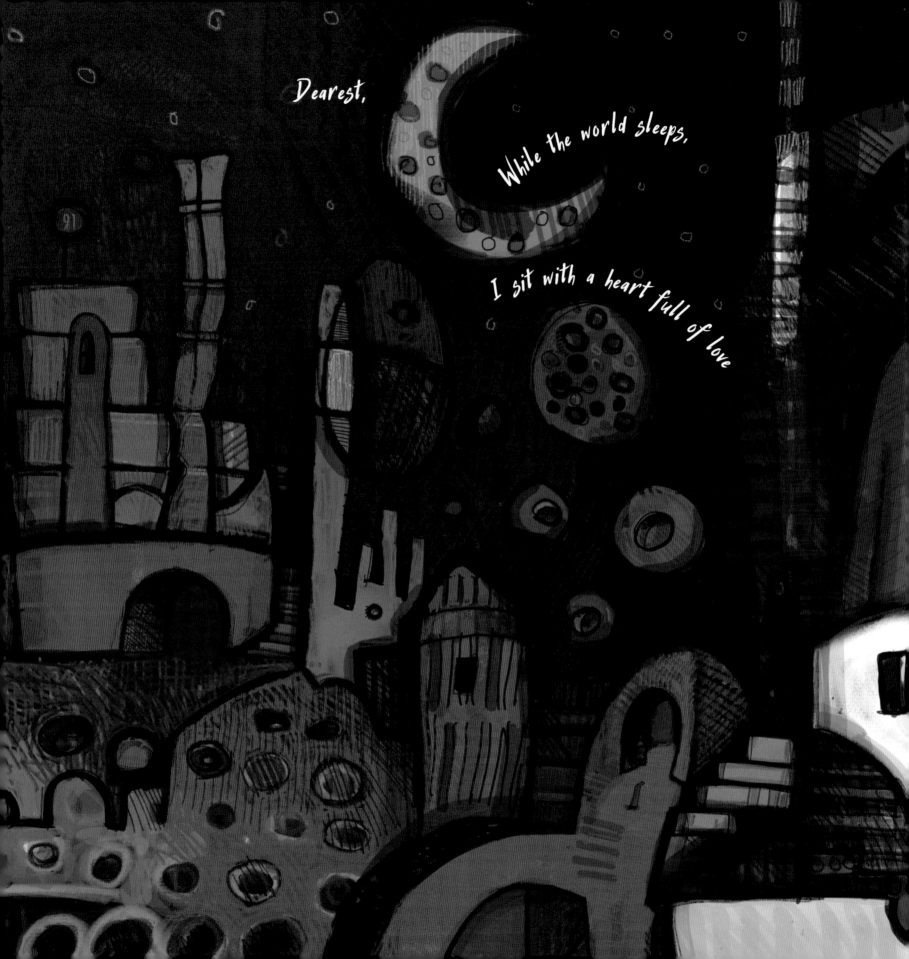

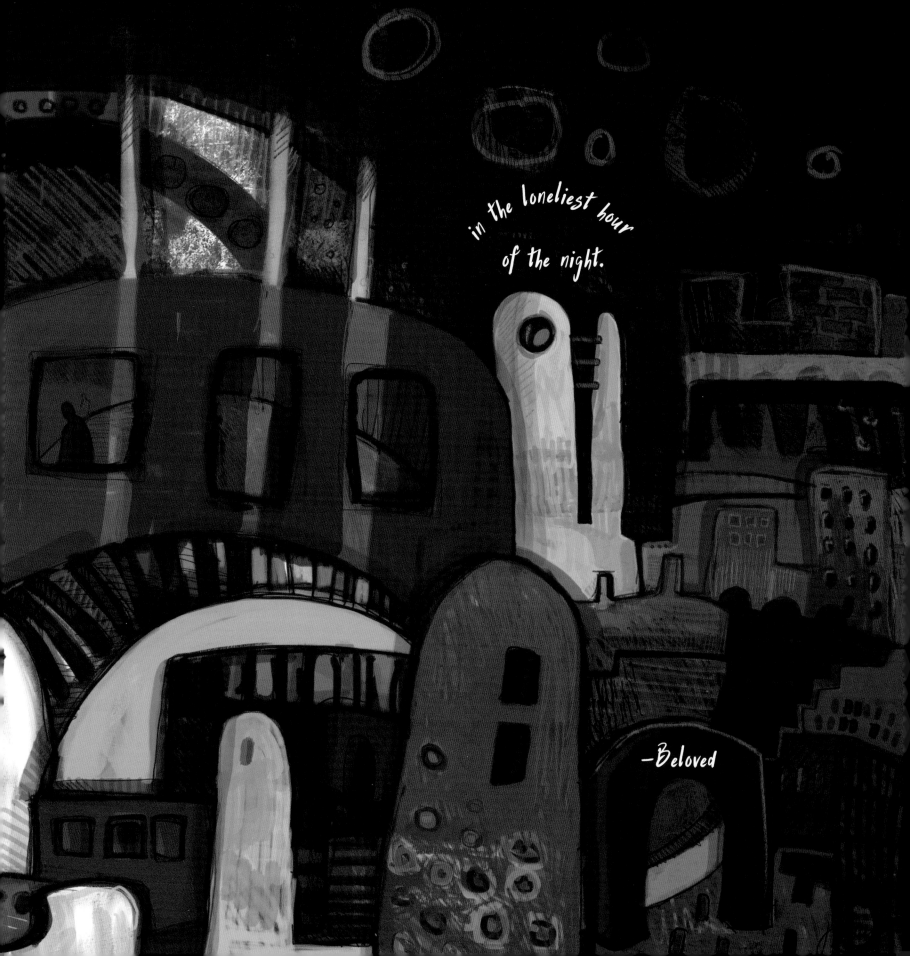

in the loneliest hour
of the night.

—Beloved

FUNERAL PREPARATIONS were easy given that Catherine had spelled out in detail what she wanted. We had a viewing at the funeral home followed by the funeral two days later. And then it was Thanksgiving. At the end of that week, everyone went home. Family. Friends. Everyone went back to their lives, except me.

For the first time in 15 years, I had to find a routine where Catherine wasn't a part of my daily existence.

I went back to work.

I took care of the children's needs.

I answered the mail and paid the bills.

It was only after the children were in bed and everything was done for the day that I got a chance to sit still. Late at night, while the rest of the world slept, was the loneliest hour for me. With nothing to distract me, I felt the full weight of love lost alone.

Soaked in Shadow

I can relate to this dark despair. I think many of us have encountered this deep hue of loneliness. A solemn figure stands in a window, in a tower, at the stairs. He is not ready to pass through that arch. The same moon that once glowed on a kiss has now dispersed into smaller circles; memories are breaking apart and floating around him in the darkness. The buildings themselves are saturated. A few elements remain bright; there is still some color in his life. Some hope.

—Jonathan Grauel

This One Time, You Stay

This image attempts to convey the raw ache of knowing that part of a journey that is traveled alone. It represents one's cry of denial, the other's sigh of acceptance.

Instead of Catherine's name, it is "dearest" that moves along the landscape. All of us, after all, have had a Dearest who urged "you stay."

Homage is paid to Hyong's paper cranes as one note that carries his Catherine away.

For the form, I chose a painted approach that is in a somewhat traditional illustration style, almost like those found in a children's book.

This approach is a nod toward the two young children in Hyong and Catherine's story and how they might begin to process the pain and loss.

—Jean Cauthen

– 92 & 93 –

THE CHALLENGE during the daylight hours was that everywhere I went, she was already there. It might be a restaurant, or a place that we had been together as a family or a couple. From Riverbanks Zoo in Columbia, South Carolina, or her parent's home in Columbus, Georgia, to the local park, to the grocery store, she was an echo from the past. I could see her and what we had done before. Any time I went where we had been before I was forced to relive the past in the present. Every day was a reminder that it was the next first day without her.

For the past 15 years, everywhere she went, I went with her and vice versa. We had been a team, awesome together! Now, this one last time, she was going to a place where I could not. I had to stay because two little lives depended on me to make sense of what had happened and to help them navigate the world. ▼

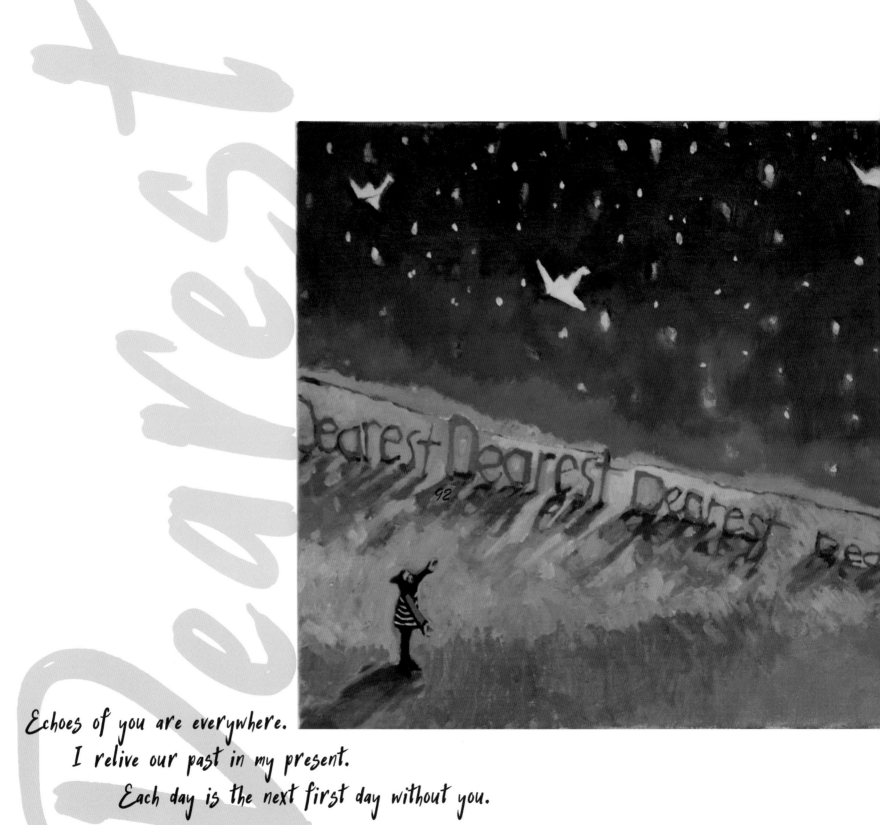

Echoes of you are everywhere.
I relive our past in my present.
Each day is the next first day without you.

Everywhere I go,
I want you to come with me.
Except this one time, you stay.

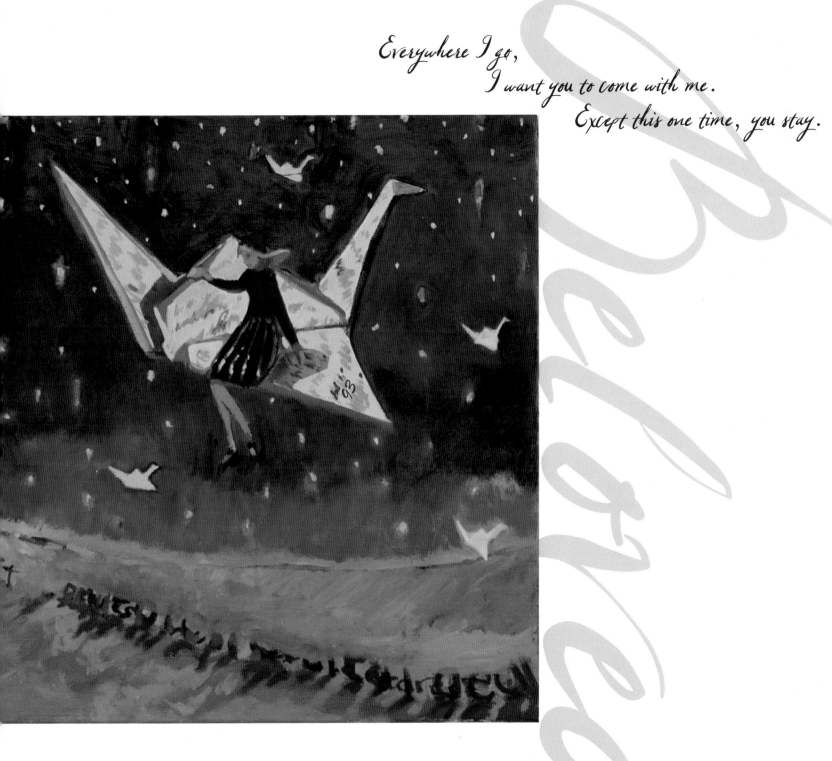

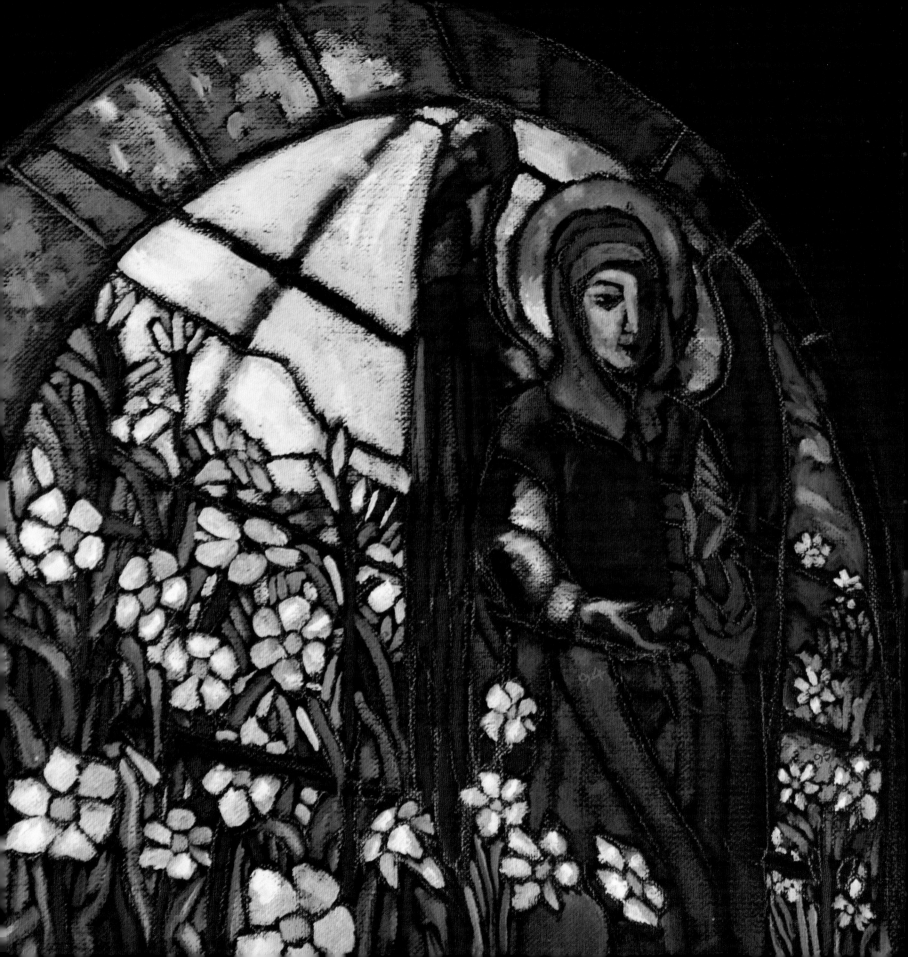

Beloved,
 Your words were perfect.
 I see what you did for our children at my funeral.
 My heart overflows with gratitude.
 —Dearest

Dearest,
 You remain in my heart.
 Your name is etched on my arm.
 I am a better man because of you.
 —Beloved

Catherine's obituary had run in *The Charlotte Observer* that Sunday. Now, we were all preparing for the funeral. It was a Tuesday morning. The skies were clear and the weather cooperated.

The Charlotte Fire Department, to whom I will always be grateful, kindly supplied two bagpipers for the occasion. The pastor used the word "hard ass" to describe her. Again, one of those memorable moments of unexpected levity that you don't forget. Then it was my turn.

I had scrawled 20 bullet points on five notebook pages that I hoped to turn into a coherent story. I knew what I wanted to accomplish: Exalt Catherine, charge the community with raising Anna and Alex, and encourage everyone to love.

I proved that Catherine was a superhero—with abilities beyond normal people, but also with an arch nemesis that ultimately was her downfall.

I asked Anna and Alex to come up to the podium so they could see how powerful community is. Jesus fills the pews on Sundays, but Mom filled the pews on a Tuesday morning. This was the community that had supported her and now this was the community charged with their care.

The final point I made was that death takes us all. Forever, while it seems such a long time, can also be only a day. We don't know when our forever will end. But when it does, how will we remember our lives? For Catherine, she knew the end was coming and she lived the days she had fiercely and completely until her forever, and mine, ended.

That eulogy was the most perfect speech I have ever given.

The days passed and Christmas neared. I had planned a gift for Catherine to reassure her that she would never be forgotten.

What can you give a dying woman that has any value?

I had her name tattooed on my arm with the phrase, "Live fiercely. Live completely." I wanted her to know that there was no way I would ever forget her. I would carry her with me until my forever ended. I think back on my life and know that with her in my heart and my life, I am a better man.

As a child, I loved looking at the stained glass windows during church.

The window featured in this piece is based on one of the windows at St. Peter's Episcopal Church in Charlotte. I imagined Catherine's spirit shining through a window during her funeral and watching through the eyes of an angel.

His words, though heart-breaking, still contain a modicum of hope. Because of her, he is a better man. Holding on to that reality allows him to look forward to the task of raising their children without her at his side.

Hyong's outstretched hand lifts his broken heart as Catherine's spirit is finally freed from her earthly body.

Daisies are present, harkening back to their first date.

—Emily T. Andress

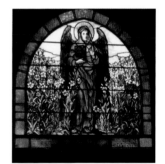

Beloved,

The sky is full of stars invisible by day.

Look up when you think of me.

I am somewhere up there.

Find me.

—Dearest

▲

— 96 —
It seems obvious when you hear it,
but "the sky is full of stars invisible
by day."

Henry Wadsworth Longfellow said it
in his poem, "Morituri Salutamus."

Whether day or night,
when you look up, the stars are there.
If you look hard enough,
you might be able to see
someone you love.

That was Catherine's request of me
and my promise to her.

Oddly enough, the poem that saddened me the most simply painted itself. I love painting trees and dark skies. Again, I didn't want flat black; there are other colors coming in and out. I used pink underpainting to give it warmth. Serendipitously, the grass became teal.

Stars in the night sky have always reminded me of loved ones who are no longer here on earth. Twinkling, smiling, looking down on us; watching over us even in the daytime when we can't see them.

This piece was inspired by THE LITTLE PRINCE, written and illustrated by Antoine de Saint-Exupery. I have an older translation that belonged to my husband's grandmother. I particularly love the part when the Little Prince says something like, "When I'm gone, I'll be a star in the sky, the one laughing, looking down at you."

And the Prince has a secret as well. Only the heart can see that which is essential; it is invisible to the eye. "The most beautiful things in the world cannot be seen or touched, they are felt with the heart."

The lone figure on the hill looking upward searches with his heart—always. Hopefully, he finds a bit of comfort in the night stars.

—Diane Pike

— 97 —

I feel privileged—deeply, insanely so—
that Catherine chose me to love.
This was a priceless gift,
the value of which
I am only beginning
to understand.
I am grateful
to her now and always
for choosing me.

— 98 —

I have spent a lot of time mourning.
From the beginning, in the hospital,
to a year after she passed,
I have cried alone
more times than I care to count.
I imagine at some point,
if she was here,
that she would just get tired
of all my moping
and tell me to get on with it.

"You've shed enough tears.
It's time now to go about
the business of living.
And don't forget, you're never alone."

I can imagine it and I hope
that I'm making her proud
by doing it as best as I can—
for myself, for our children,
and for her. ▼

There is a warmth to this piece, and yet there are tears as well. Embedded in the image are snippets of their journey, but there are also figures moving foward.

Instead of solely buildings and inorganic shapes, there are plants, a cross section of soil, symbolizing growth, watered by tears.

There are figures in a tear; a figure as a seed in the field, thriving; choosing. The dandelion fluff wishes have taken root, and flowers bloom.

Sometimes you have to battle through grief to grow. Security lies in moving forward, in living fiercely.

— Jonathan Grauel

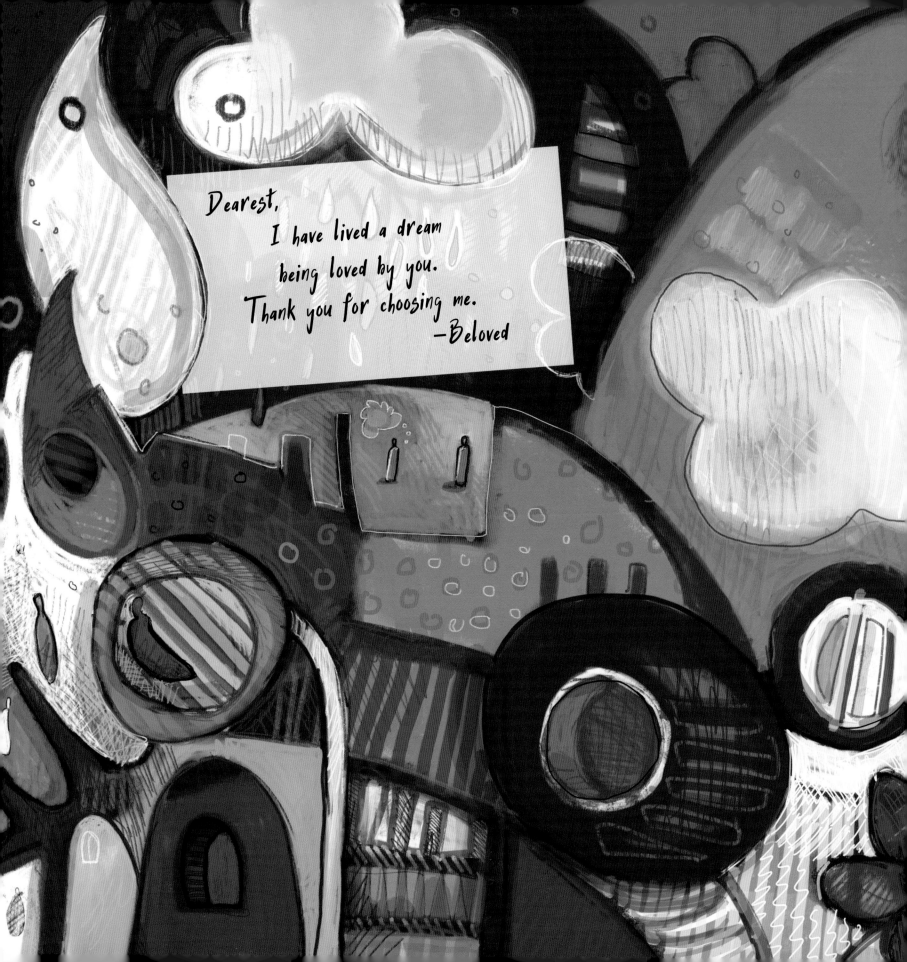

Dearest,
 I have lived a dream
 being loved by you.
Thank you for choosing me.
 —Beloved

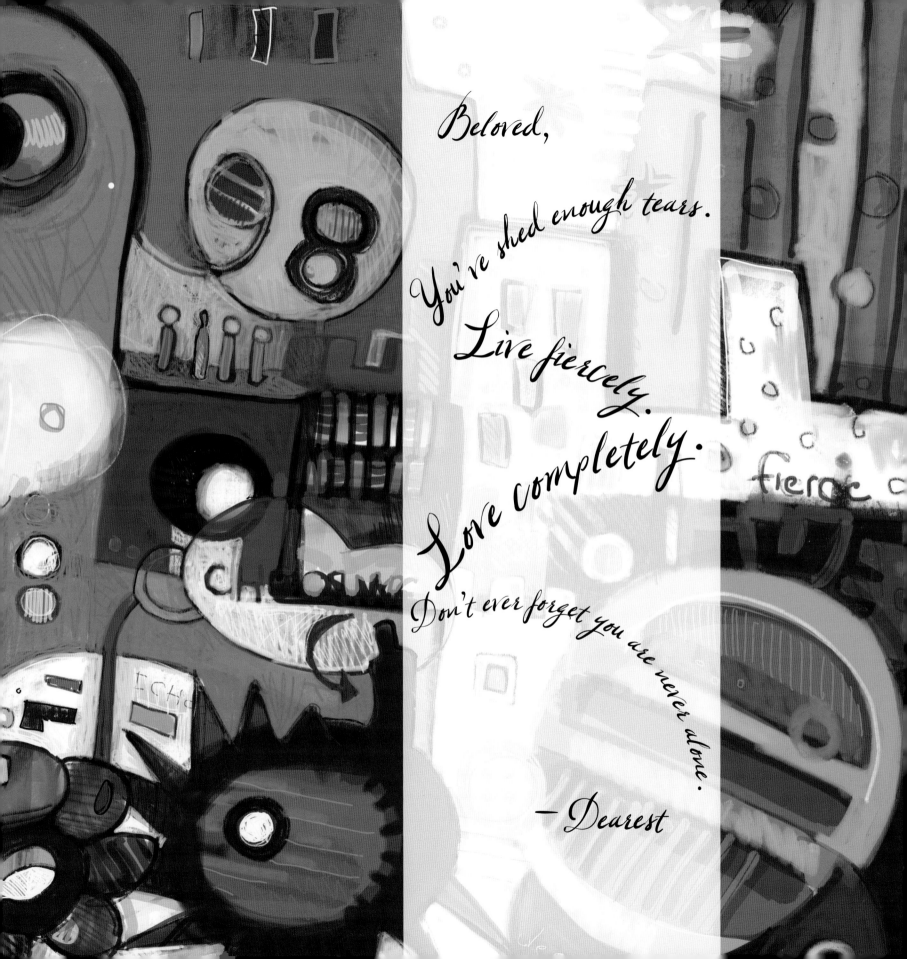

Beloved,

You've shed enough tears.

Live fiercely.

Love completely.

Don't ever forget you are never alone.

— Dearest

Dearest,
 However long it takes,
when I'm done on this earth,
 I will find you.
 —Beloved

▲

— 99 —

As dawn heralded another day,
kneeling beside her still body,
I made her a promise.

When my forever is up
and I am done on this earth,
I will find you.
It was a promise
between her and me
and whatever angels were listening.

My final promise.

I was most unsettled by this last piece. We're so small in this vast universe. At the end, you can't believe you have to let go, and you hope that something/someone will catch you when you venture out into that universe.

I am interested in the non-material world, what we cannot see or hear. I explore that in my art. These shapes recur in my work; maybe they are planets. I don't know what they mean or represent—whatever it is that is out there.

I am very appreciative for the opportunity to be part of this project. 100 Love Notes *brought me unexpected healing.*

—Rebecca Haworth

I imagine this final note as a missive of love from above. When I first came across Hyong's 100 Love Notes project, I will not lie, tears were shed. I lost my dear mama a few years ago, so their story really hit close to home.

I'm pretty sure I first heard about #100 Love Notes on Mashable or another site that featured Hyong's story. I looked at the 100 Love Notes website and read through all the notes (and ended up in tears). Soon after, I posted about it on Instagram and eventually "met" Hyong.

I truly believe that Hyong and Catherine's love exists far beyond this earthly realm and this piece is my small tribute to their inspiring story.

—Ria Rivera

— 100 —

One day, driving in the car
to a place I no longer remember,
we heard a Whitney Houston song,
"My Love Is Your Love."

Immediately, we knew
that if we were to have a song
that captured our life together
that was it.

So I imagine
her last words to me,
and her first words to God,
would paraphrase that song.

▼

Beloved,

When judgement day comes,
I will say to the Lord
I lived fiercely and loved completely
With you.

 Dearest

epilogue

I T HAD BEEN my intention that distributing 100 love notes would be an individual act. My children and I would hand them out and go about our day. What I have learned is that individual acts of love can have a worldwide impact.

The local news outlets (paper and broadcast) covered it. The story spread and the *Kansas City Star*, WTVR (in Richmond, Virginia), *Miami Herald*, *The Chattanoogan*, WFSB (in Connecticut), and the *Sacramento Bee* picked up the story as well. #100LoveNotes was also covered by national news programs, such as *Good Morning America*, *The Today Show*, and ABC and NBC *Nightly News*. Internet news publications, such as *People Magazine*, and aggregators, such as Buzzfeed, HuffingtonPost (UK), and Upworthy, also ran versions of the story.

International news coverage also came very quickly. *Sky News* in the United Kingdom may have been the first. The *Toronto Star* ran coverage on it. I did an interview with a Korean news outlet via Skype. I did an interview for *Vanity Fair* (Italy). Versions of this story ran in Portugese, French, Vietnamese, Hindu, Spanish, Arabic, Croatian, Korean, Chinese, and many other languages, too many to keep count.

I've written articles for *The Charlotte Observer* and *Carolina Bride* magazine. The American University magazine as well as the University of Virginia magazine have covered the story of love.

However, the most gratifying part of this whole experience has been watching love spread around the world. I can literally say that I saw love spread around the world. I could see it spread initially locally, then nationally, then internationally—country by country, continent by continent, even Antarctica! Using social media tools, the last time I checked in January of 2016, the hashtag #100LoveNotes, had been viewed tens of millions of times.

People have shared their love for one another through Facebook, Twitter, and Instagram posts. Even nine months later, love still continues to spread as new viewers find the website (www.100LoveNotes.com) and the Facebook community page.

What to make of all this?

Love transcends geography, political boundaries, languages, culture, age, and distance. We all know what love is. Whether experienced in a romantic context through marriage or dating or platonically as family or friends, we have all experienced love. Yet, many of us still need reminders of how precious it is and not to take it for granted. I have learned, through my own loss, that even the deepest, most profound love can't last forever. And forever can be much shorter than planned. So my wish for everyone is that they have the time and opportunity to embrace the love in their lives, reflect on it, and be moved to act—in some fashion—to acknowledge it.

Whether it's a handwritten note, freshly baked cookies, chalk art, or something else, I wish for lovers to take the time to express the love they have for the people in their lives. Whether a private or public act, shared via social media, or a secret between two lovers doesn't matter. What matters is that we hold love close and are moved, through acts of love, to make it real and present.

It was lots of fun working with foam, the heated string made it easy to cut. I made a bunch of stuff that me and my mom and dad liked. (There's stuff that my sister likes, too, like the Mickey head.) Once I had the baseboard I added the rectangular objects which represent the love notes. I grouped the city pieces together, the building where Dad works, and a street sign that says Mom Street and Dad Street. The plane represents the places where we flew and the car because we drove to Colorado which took a **long** time. And there are musical notes and a really tall speaker because Mom LOVED techno music. Teal is a theme so I painted teal ribbons on the base. I really liked using the mosaic tiles and think that I'll use those in the next art piece I do. They just feel really good in my hands for some reason. The tree is the last thing I did and it is there twice to show the different seasons.

—Alex Yi

The first thing I planned was a giant Mickey Mouse, decorated with a bunch of cool stuff. I could see hanging it in my room, above my bed. But this project had a different purpose so I went another direction and made this 360° piece.

I'm not the most sentimental person, but the tree is symbolic and became more symbolic as I hung hearts and love notes on it. I heard a story that when someone dies, sometimes they come back as a bird, so the red bird in the tree is my mom's spirit. For the word LOVE I did some zentangling with gel pens, which was a lot of fun. (Note to Dad: I have not abandoned my first idea.)

—Anna Yi

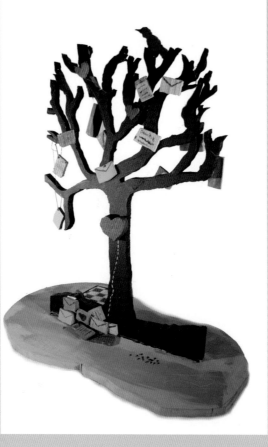

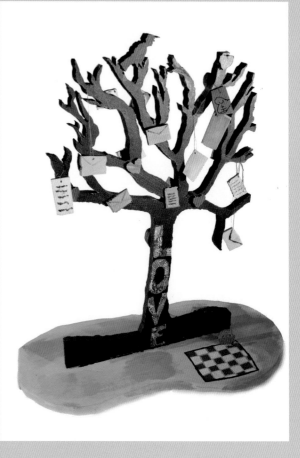

WHAT WAS GOING to be a one-time event has taken on a life of its own. I never would have seen myself as a public champion of love (good financial stewardship yes! Love? Never saw it coming), but now I see this as my greatest purpose—to be love's champion.

Since the day the love notes were handed out, a tree's been planted at the University of Virginia in Catherine's name. It even has a laminated note that gives Catherine a voice, encouraging students to make use of the tree for shade, picnics, and even shenanigans.

A foundation has been started to put resources behind the mission of spreading love.

And this book is the final testament to the person that Catherine was and how one man who learned to love because of her is moved now to embrace love as the core purpose of life.

Finally, this is the great thing about love. Unlike commodities that diminish with use (think oil as an example), the more one takes of love, the more one is likely to give. Imagine a world filled with love and that love serving as the basis for the choices we make. It would be a world that we all would want to live in.

So to you, dear Reader, I hope you too will be a champion of love—in your life and of those around you.

I encourage you to take the time to write love notes to family and friends. To help you start, inside the back cover of this book, is a blank notecard.

Use it.

Spread a little love.

Be a champion.

acknowledgments

This collaboration between writer, artists, and designers
has resulted in a book worthy of love.

I wrote words that served as inspiration for artists.
In turn, they took the words and gave them a visual life.
Alone, each is capable of evoking emotion.
Together, they are even more powerful.
And lastly, a designer married the two onto the same page,
adding her own artistry and giving life to something entirely new.

For all their help in getting this book completed, I am grateful.

It would not have been possible without their artistic vision
and editorial urging. And to all the unseen supporters who
proofread early drafts of the love notes and
supported the artists, they also deserve thanks.

I would like to especially thank Caroline, Laura, Michelle, Sue,
and Valerie, for transcribing Catherine's words in a more feminine
hand on the original notecards that we distributed in 2015.

In this endeavor, I learned that putting a book together takes
a community of committed souls
working together to create something new
that would not exist if we worked alone.

Ee

The thunder egg was adopted as our state rock in 1965. They are plain on the outside but inside have a variety of beautiful designs and vibrant colors. They are 20-40 million years old.

According to Native American legend, the rocks come from the Thunder Spirits who lived on the peaks of Mount Hood and Mount Jefferson. During thunder and lightning storms they fought and threw the massive eggs of the mythical thunderbird at each other. Millions of thunder eggs are scattered at the base of these mountains.

Our most famous rock is not a thunder egg but a meteorite. The Willamette Meteorite was discovered by farmer and miner Ellis Hughes in 1902. Scientists believe it originated in the asteroid belt between Mars and Jupiter before hitting the small community of Willamette 10 thousand years ago. The size of a small car, it weighs 30 thousand pounds and is the largest meteorite ever found in the United States.

E is for Egg,
 but not the kind you eat.
Oregon's rock is the Thunder Egg,
 made by volcanic heat.

Ff

The John Day Fossil Beds National Monument was established in 1975. This 14,000-acre park is divided into three separate units: Sheep Rock, Clarno, and the Painted Hills. Over 40 million years of Oregon history can be seen in these rock formations. They are the richest fossil beds in North America. This area was once a semitropical forest and home to over a hundred different animal species including saber-toothed tigers, camels, sloths, and rhinoceros. The Clarno unit has fossils of over 300 plant species. The colorful streaks in the Painted Hills unit were created by volcanic ash erosion. The Sheep Rock unit has a museum featuring exhibits of fossils.

Thomas Condon was a pioneer, teacher, author, clergyman, and geologist who came to Oregon as a missionary in 1853. He was the first scientist to study the fossils in the John Day region and became Oregon's first state geologist.

F is for Fossils.
Find them near John Day.
Camels, sloths, or saber-tooth,
their prints are on display.

Gg

The Columbia River Gorge is 80 miles long and up to 4,000 feet deep. The river is an important means of transportation through the Cascade Mountains. One of the most visited areas along the gorge is Multnomah Falls. Fed by underground springs from Larch Mountain it cascades 620 feet down to rocky pools, making it the second highest year-round waterfall in the United States. On November 17, 1986, President Ronald Reagan signed into law an act creating the Columbia River Gorge National Scenic Area. It is our nation's only National Scenic Area. The Historic Columbia River Highway was the first modern highway in Oregon and the first scenic highway in the United States.

G is also for our state flower, the Oregon Grape, which grows through-out the state.

G is for the Gorge
where the Columbia River runs.
See rocky cliffs, waterfalls,
and windsurfers having fun.

The Hells Canyon Wilderness area runs along the Oregon and Idaho border. Here the canyon is nearly 8,000 feet deep which makes it the deepest canyon in North America and the deepest river gorge in the world. Plans were made to build a dam across the Snake River in the area of Hells Canyon but no one could decide who should do it. A man named Floyd Harvey didn't want a dam at all. He started contacting people to stop the dam. The question was eventually brought before the Supreme Court. The court ruled that the Federal Power Commission should give greater consideration to not building the dam at all! It was a wonderful surprise which gave Floyd Harvey more time to persuade people that it should be left alone.

On December 31, 1975, a 71-mile stretch of the Snake River through Hells Canyon became a National Recreation Area preserving this beautiful place.

H is for Hells Canyon.
Did you know?
It's one of the deepest in the world.
Watch out below!

I i

Crater Lake was created when Mount Mazuma erupted over 6,000 years ago. At 1,932 feet deep, it's the deepest lake in the United States. Wizard and Phantom Ship are two islands that appear to float on top of the lake. The blue waters come only from snow and rain.

In the mid 1800s a Kansas schoolboy named William Gladstone Steel read about Crater Lake in a newspaper used to wrap his lunch. William's dream was to see the lake for himself. When he was 18 years old his family moved to Portland and 13 years later his dream came true. In August 1885, William stood on the rim of Crater Lake. He was so moved by the beauty of the lake he began campaigning and gathering signatures to protect the area. In 1902 President Theodore Roosevelt signed a bill making Crater Lake Oregon's only national park. Without William Gladstone Steel's dream and hard work it might not have happened.

I is for Island.
Crater Lake has two—
Wizard and Phantom Ship
on top a lake so blue.

The Nez Perce tribe lived in the Wallowa Valley in northeast Oregon. Early settlers wanted to farm this fertile valley, so the federal government tried to purchase the land from the tribe. The Nez Perce refused and the government ordered them onto a reservation. They fled to the safety of Canada. Just before reaching the border, soldiers captured most of them. In the end they were forced onto a reservation.

Upon surrendering, Chief Joseph told the soldiers, "It is cold and we have no blankets. The little children are freezing to death... Hear me, my chiefs! I am tired. My heart is sick and sad. From where the sun now stands I will fight no more forever." Chief Joseph never again lived in the Wallowa Valley.

There is now a town in the Wallowa Valley named after Chief Joseph. Joseph is an artist community and a recreational area. Hot air balloonists have found this valley one of the nicest views ever.

J j

J is for Joseph,
a Nez Perce tribal chief.
They took his land forever,
causing his people grief.

K k

A horse of a different color
is what some people say
about the Kiger mustang
which starts with the letter **K**.

Kiger mustangs were found in the high desert area near the Steens Mountains. For years they were forgotten in this rough and remote part of Oregon. The horses are believed to be the most pure descendants of the ancient Spanish breeds first brought to North America by the conquistadors centuries ago. Named after Kiger Gorge, they are now sought after for their beautiful and unusual coloring. They sell for thousands of dollars.

K is also for the Klamath Basin. Upper Klamath Lake, located in this basin, is our largest lake and one of the best bird-watching areas in the state. Canada geese, pintails, mallards, American White pelican, double-crested cormorant, heron, and other birds use this lake during their annual migrations. The basin also has the largest number of wintering bald eagles in the lower 48 states.

L is for Lion
with a different kind of roar.
These live and play in caves
along our rocky shore.

The Sea Lion Caves located on Oregon's coast are the largest in the United States. Over 25 million years old, the main cave is as long as a football field and about as tall as a 12-story building. Hundreds of Steller sea lions live in the safety of this natural sanctuary.

Steller sea lions are marine mammals. They gather inside the caves during fall and winter. During spring and summer they have babies on the rocky ledges outside. The babies (called pups) weigh 40 to 50 pounds and are about four feet long. They grow rapidly and can reach six feet in one year. Females (called cows) average nine feet in length and weigh up to seven hundred pounds. The males (called bulls) average twelve feet in length and can weigh up to one ton. They eat mainly fish, squid, and octopus.

In December of 1972 the federal government created a law prohibiting the killing, harassment, and capture of any marine mammal.

Ll

M is for Marionberries,
an original Oregon sweet.
Eat them plain or make a pie,
a perfect summer treat.

Marionberries are Oregon's number one caneberry crop and are in demand all over the world. George Waldo, a berry breeder with the Agricultural Research Service in Oregon, developed them. The berry is a cross between two other blackberries, the Chehalem and the Olallie. Marionberries have small seeds and an excellent flavor. They were named after Marion County where they were first tested in 1956. Oregon is the leading producer of caneberries in the United States.

Our state beverage is milk. Drink a tall glass of cold milk with a piece of pie!

M is also for McLoughlin. Dr. John McLoughlin is known as the "Father of Oregon." He was given this title because he helped so many pioneers after their hard journey across the Oregon Trail. The Native Americans called him the "White Headed Eagle" because of his white flowing hair. His house is located in Oregon City and is now a museum and national historic site.

M
m

N n

Bill Bowerman was born in Fossil and graduated from the University of Oregon where he was a coach for 24 years. He is known as the man who brought jogging to America. A kitchen waffle iron gave him an idea—he would make shoes with waffle soles to run faster. Phil Knight was a member of Coach Bowerman's team and later became his business partner. Together they started a company called Nike. Nike was named for the Greek goddess of victory.

Oregon may have the newest in athletic shoes, but it also has the oldest shoes. A pair of 10,000-year-old sagebrush sandals were discovered in Oregon. These sandals are the oldest shoes ever found in North America.

Our state nut is the hazelnut but many Oregonians prefer to call it a filbert. Oregon supplies 99% of the world's hazelnuts. That's a lot of nuts!

BEAVERTON

EUGENE

N is for Nike,
one coach's dream
about a better shoe
to help his team.

FORT ROCK

The Oregon Trail was the largest voluntary human migration in history, bringing over 300,000 pioneers to the western frontier during the 1800s. It was called "Oregon Fever." Starting in Missouri, the journey was over 2,000 miles long. Some pioneers had wagons but most walked the entire way. Two women important to Oregon's history came over this busy trail.

Abigail Scott Duniway traveled to Oregon when she was seventeen. Her mother and youngest brother died along the way. She became a schoolteacher, married, and had several children. She started a newspaper called the *New Northwest*, becoming an active spokesperson for women's right to vote. In 1912, at age 78, she became the first woman to vote in Oregon.

Tabitha Moffatt Brown, a widow, came to Oregon when she was 66 years old. She started a home and school for orphans that eventually became Pacific University, now located in Forest Grove. She was called the "Mother of Oregon" for her charitable and compassionate work.

O is for the Oregon Trail
bringing wagonloads of pioneers
traveling from Missouri
with plans for new frontiers.